Transparency in Textiles

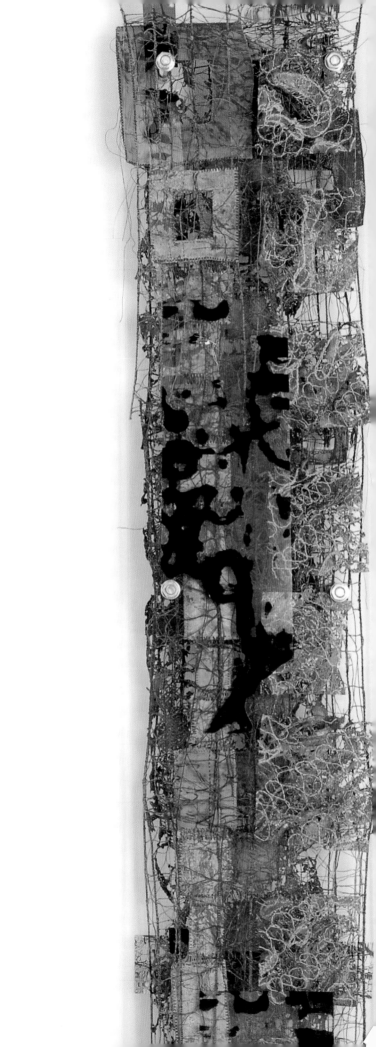

Transparency in Textiles

DAWN THORNE

BATSFORD

Dedication

This book is dedicated to my Father, John Joseph James, whose great artistic talent always encouraged me to find my own way. An exceptional man in many ways. To those that knew him it has been a privilege. My hero and inspiration. Thanks Dad.

First published in the United Kingdom in 2009 by
Batsford
10 Southcombe Street
London
W14 0RA

An imprint of Anova Books Company Ltd

ISBN 978 1 9063 8848 5

A CIP catalogue record for this book is available from the British Library.

17 16 15 14 13 12 11 10 09
10 9 8 7 6 5 4 3 2 1

Reproduction by Rival Colour Ltd, UK
Printed and bound by Craft Print Ltd, Singapore

Distributed in the United States and Canada by Sterling Publishing Co., 387 Park Avenue South, New York, NY 10016, USA

This book can be ordered direct from the publisher at the website www.anovabooks.com, or try your local bookshop.

Right: Sketchbook page with design work showing transparent layers in tissue paper and wax.
Opposite page: Shot organza layered and gathered with stitch.

Contents

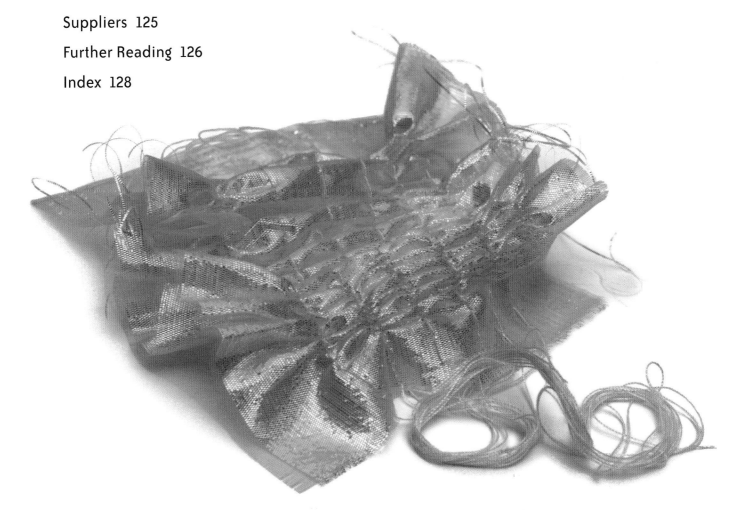

INTRODUCTION

Back in the 1970s, when I had just started my teenage years, I was given a hobby kit called Plasticraft™. For me, this was the most amazing and inspirational gift. The idea was that you would trap small objects into a clear plastic block, which was then backed with a coloured plastic in liquid form. A ceramic mould was supplied with a range of different shapes and sizes to choose from. The whole process took a few days, as it took time for the layers to set and the finished shapes to become completely hard. Once hardened, the plastic could be turned into rings, cufflinks, brooches and paperweights.

That kit has remained one of the most memorable and exciting gifts I have ever received; even now, some thirty years later, it still manages to excite me.

Looking back, plastics have always fascinated me: the wonderful colours, the edges that glow, the feel, handle and texture of matt surfaces that contrasts with the glassy, transparent quality of perspex and acrylic. Some plastics are rigid, bendy, springy and pliable, and all extend their potential when combined with textiles.

Many types of plastic are covered in this book and you will see how, with careful consideration and selection, these offer additional materials with which to explore levels of transparency, low relief, form and dimension that could inspire future textile work.

In addition to the plastics, we will look at ways of translating and creating translucent fabrics and surfaces with waxes, oils, fibres, fabrics and thread. You will also learn how to select and interpret inspirational sources that are then taken forward into design exercises specifically aimed at transparency and structure. Looking at the three-dimensional form requires more than one viewpoint.

To add to the thrill, methods of incorporating lighting into your work, using fibre optics and conventional lighting approaches, are demonstrated.

We all have a passion for what we do and sometimes we can't contain our excitement when challenged to play and experiment with the new products that continually cover the pages of magazines and publications. To this end, I hope to challenge and inspire you with my own passion for transparency and structure.

Have fun and enjoy!

Right: Jute fibre, handwoven into a machine-made grid and embellished with further machine stitch.

Below: An example of traditional reverse appliqué in black cotton applied onto a sheer organdie fabric, which allows light to filter through the turned-back areas.

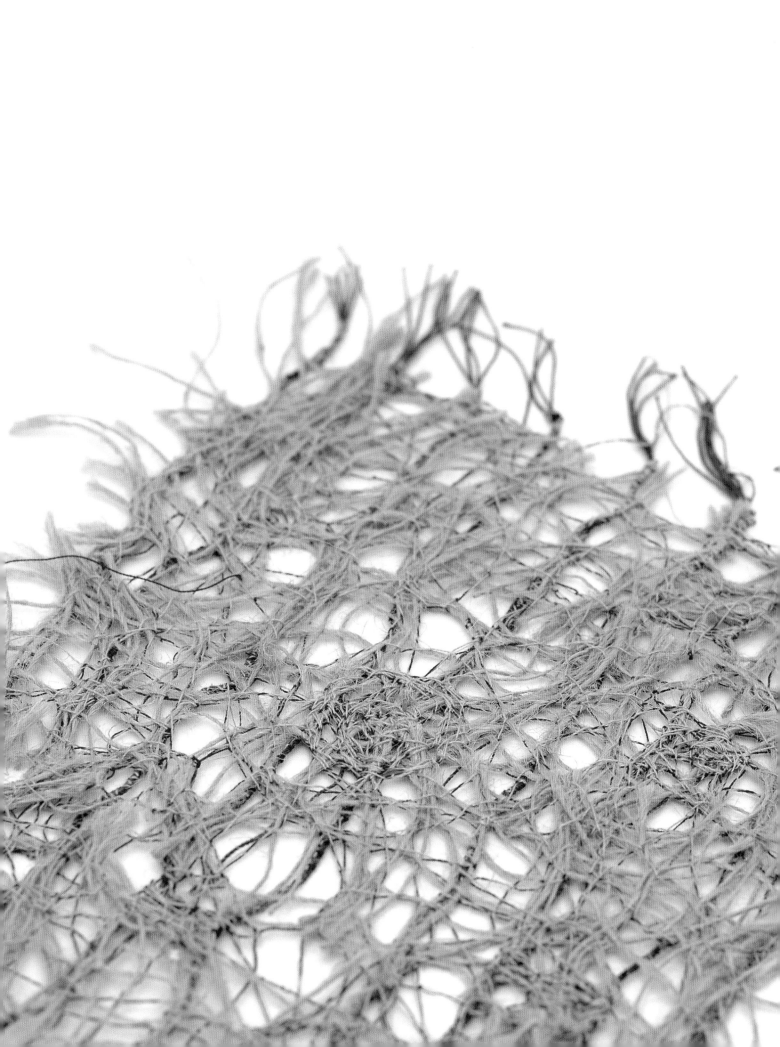

1 Materials and Equipment

In this section, I have listed some of the materials and equipment you will need for the processes covered in this book. Most of the items can be sourced through the internet, hardware stores and garden centres, as well as the more usual art and embroidery outlets. Some of the tools I have used are available from specialist suppliers. In many cases, you can utilize items you have around the house.

Art and design materials

Wonderful coloured surfaces and textures can be achieved relatively easily using a range of colouring media. Commercial dyes are readily available and easy to use to add colour and designs to natural and synthetic fabrics, and flourishes of sparkle and iridescent shimmers can be applied with Markal Paintstiks, bronzing powders and metallic rubs. Try using the following:

- Acrylic paints
- Gouache
- Brusho
- Water-soluble crayons
- Markal Paintstiks
- Bronzing powders
- Graphite and charcoal
- Fine liners
- Transfer paints
- Acid, Procion and disperse dyes
- Treasure Gold wax gilt
- Metallic rubs

Left: Brusho paints.

Threads and fibres

There is a huge array of embroidery threads available, in amazing colours, some variegated or shaded, as well as in seductive textures – thick or thin, matt or shiny. All these threads increase the range of your palette and can be used to add embellishment to your work, from the simplest marks to rich, heavily worked surfaces, as well as being used in the construction process. In addition to embroidery threads, there are also a number of different fibre types that can be used in a variety of ways in their unspun state. These fibres offer the potential to create delicate and translucent fabrics and papers, as well as adding interest to store-bought fabrics. You could use:

- Silk fibres and wool tops
- Cellulose
- Sisal fibre, kozo fibre
- Embroidery threads, both hand and machine

Below: An example of the devoré technique used on acid-dyed silk/viscose velvet. In the places where the pile is removed the design becomes see-through.

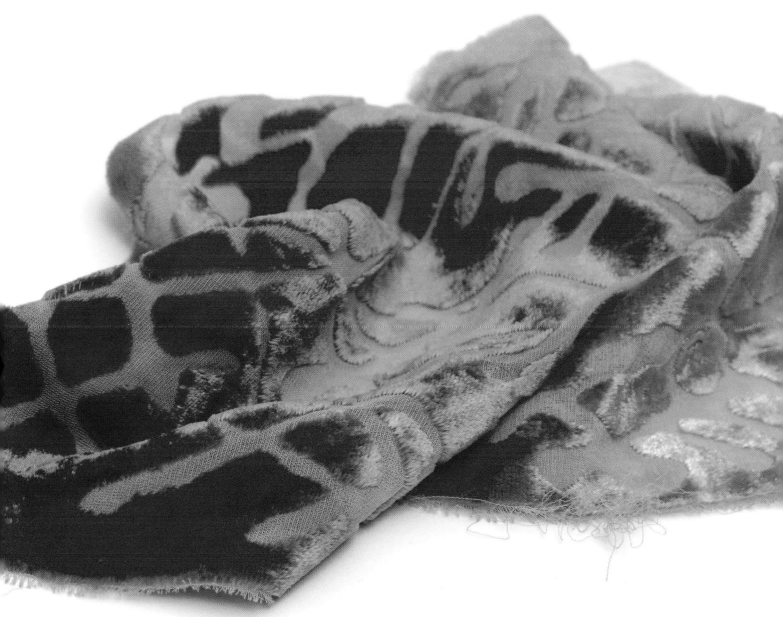

Woven fabrics

Woven fabrics are ones that have a weave: the warp (vertical) and weft (horizontal) threads. The way that weft threads are woven in and out of the warp threads gives the variety in weave patterns. In evenweave fabric, the warp and weft threads are spaced evenly over the entire cloth. By altering the thickness of the threads used, a whole range of different weights of fabric can be produced, from the most delicate chiffon and silk mousseline to heavy canvas and sacking (burlap). There are many translucent woven fabrics to choose from, including the following:

- Sheers: chiffon scarves, synthetic sheers
- Silk chiffon, organzas and organdie
- Plastic netting
- Cottons: calico, scrim, muslin, fine lawn

Below: A plain white synthetic voile fabric, to which colour has been added using disperse dyes. The transparent quality of the fabric allows for subtle shading when it is layered over a solid-coloured fabric.

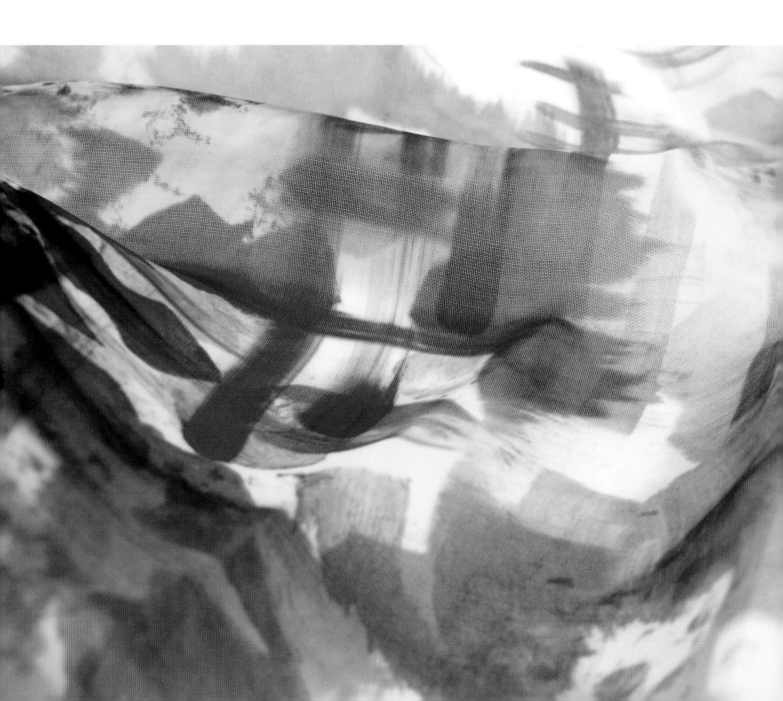

Non-wovens

Non-wovens is a collective term for a wide range of materials, many of which have been used to create the looks and finishes in this book. These non-wovens are all man-made and fall into two categories – those that react with water and those that react to heat.

SOLUBLE AND DISPERSIBLE FABRICS

Soluble fabrics can be stitched; once stitching is complete, you can simply wash away the fabric with water, leaving just the stitch.

- Solufleece is a fabric-like soluble that allows you to trace or draw your design directly onto the surface with ease.
- Soluthick is a similar fabric but, as the name implies, it is a thicker product. This is useful if you intend to stitch heavily or attach fabrics and additions.
- Romeo is a durable clear PVC-like film, which is cold-water dissolvable. Your design can be drawn on or you can put the fabric through an inkjet or laser printer (using a sheet of paper as a carrier). It can be stitched without a hoop.
- Giulietta is a lighter-weight, clear, cold water-soluble film that can also be put through the printer. This does need to be put into a hoop for stitching.
- Solusheet water-soluble paper will also go through the printer and can be stamped and coloured. Using a brush and water, you can carefully remove sections of paper, leaving areas of stitch as well as print and paper.
- Aquabond water-soluble fabric is similar to Solusheet, but has a sticky adhesive side. This allows fabrics, threads and so on to be positioned in place without fear of movement or displacement when free machined.

HEAT REACTORS

- Horticultural fleece is available from garden centres and is a fine, soft non-woven fabric that is designed to protect vegetation from frost and cold weather. It can be coloured with acrylic or fabric paints; it can also be stitched into, and reacts brilliantly to heat. Once stitched, it can be zapped with a heat gun.
- Lutradur is a non-woven fabric made from spun polyester. Its surface is strong and robust, it takes colour well and can be coloured with pigment-based paints, Paintstiks and acrylics, or transfer paints and disperse dyes. It can easily be cut, sewn by hand or machine and reacts beautifully with the heat tool and soldering iron.
- Evolon is a new microfilament fabric that has the softness, look and drape of a traditional fabric. Like Lutradur, Evolon can be cut, sewn and coloured, and because of its polymer mix it can also be acid-dyed. It can even be printed via a computer. The fabric also reacts to a heat tool or soldering iron to create distressed effects.

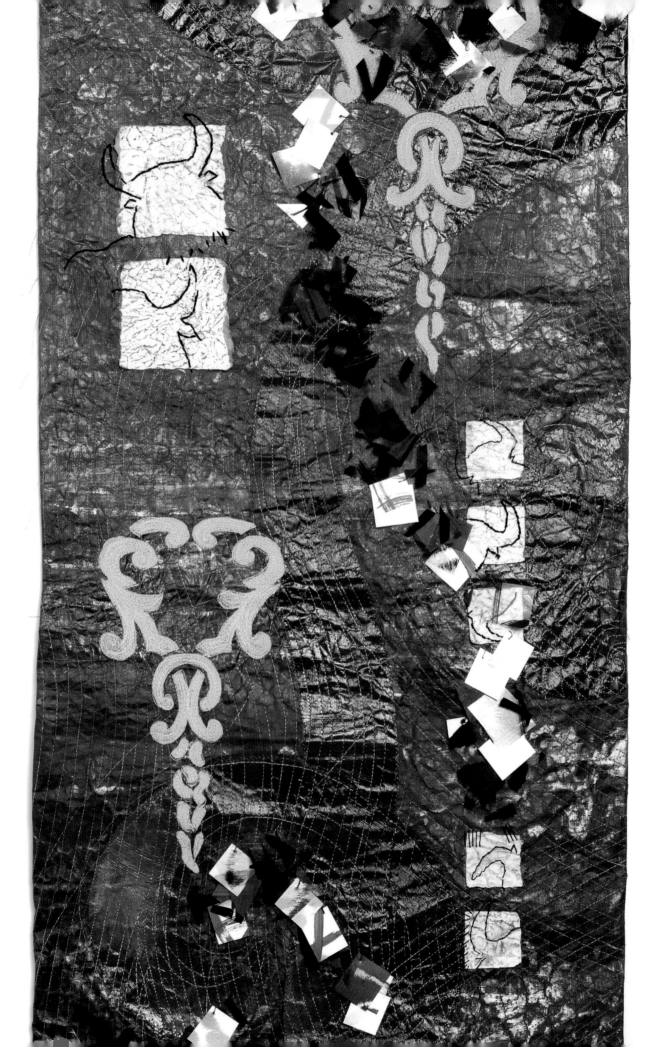

Papers

There are many different types of paper available. Most can be treated to create transparent effects, or exhibit sheer qualities when used as a design tool for transparent work. Papers can be cut, glued or layered to achieve interesting results. Useful types include:

- Tissue paper
- Glassine
- Drafting film
- Cartridge paper

Plastics, films, resins and gels

We come into contact with a number of these materials daily: cellophane wrap from a bunch of flowers, plastic file pockets from the stationery store, and packaging. They can provide crystal-clear overlays or offer light-diffusing qualities. For example, you could try:

- PVC
- Acrylic sheet
- Casting resins
- Acrylic gel media

Metals

Metals can give shimmer, support, structure or additional embellishment to your work, as well as providing interest to surfaces. Useful metal items include the following:

- Wire
- Aluminium tube and sheet
- Steel rods and tubes
- Metal mesh

Tools and equipment

When working with some of the materials explored in this book, you may need additional equipment that is not necessarily familiar to the textile artist. One item from the list that will be familiar, however, is the sewing machine. Also consider:

- Laminating machine
- Jeweller's tenon saw and metal files
- Wet-and-dry sandpaper
- Glue gun
- Cordless drill
- Iron
- Heat gun
- Blow torch
- G-clamps
- Craft knife and cutting mat
- Soldering iron

Above: Three layers of transparent fabrics joined together with a network created with a glue gun. When the piece is held up to the light a stained-glass effect is achieved.

Opposite page: *Quiet Reflection* by Dawn Thorne. Waxed and oiled paper quilt with photographs and screen-printed additions, plus hand- and machine-stitch embellishment.

2 Creating Translucent Surfaces

In this chapter of the book we will look at different ways of creating transparent and translucent surfaces in your work. For example, the surfaces of papers can be altered using oils and waxes to make them translucent, and these effects can also be used as part of the design process to help you visualize effects you will later render in stitch. This chapter also discusses fabric treatments that help give the impression of transparency and translucency, even though the fabric may remain opaque. There is also information on weaves and creating woven structures and fabrics, and how to combine fabric and paper, layering and manipulating them to create relief and dimension.

Below: A range of synthetic and natural sheer fabrics, showing varying levels of translucency.

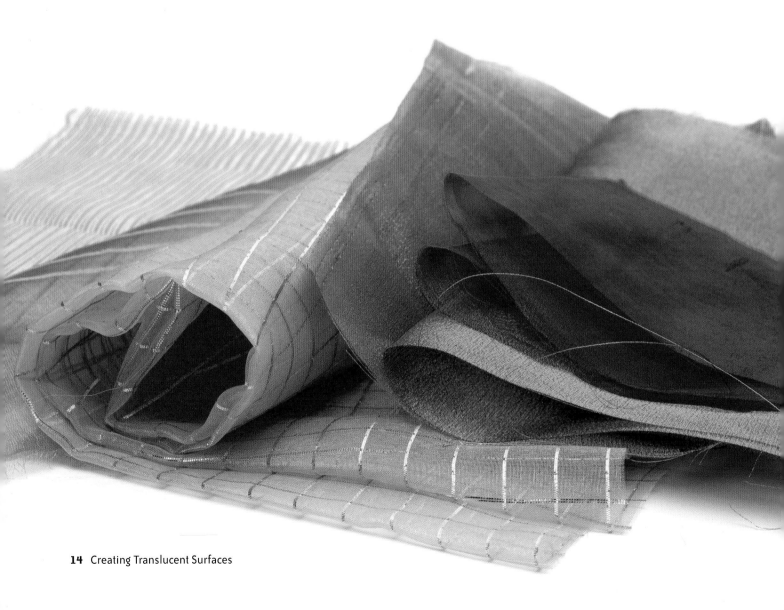

Fabrics

A vast range of transparent fabrics, with varying levels of translucency, is available to the textile artist. Some are almost opaque and only reveal their see-through quality when held up to the light; others are so sheer that they offer only a hint of colour; while there are many other fabrics that have their place somewhere in between the two extremes. These sheer fabrics may be made from either natural or synthetic fibres, and lend themselves to a range of applications.

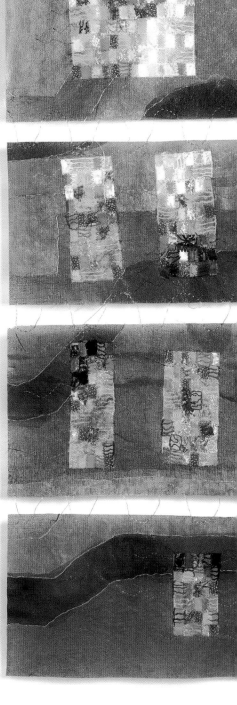

- The finest of all sheer fabrics is synthetic chiffon, and the finest of these is sold in the form of chiffon scarves. Other synthetic sheers include organza, crystal organza and voiles, to name but a few.
- Natural cotton organdie has a wonderful crisp handle, which can provide exciting sculptural qualities.
- Silk sheers are useful and can be purchased in wonderful shot colours, in which the warp and weft are two different colours, giving added depth to a piece of work, as well as luscious and vibrant hues.
- Synthetic fabrics are also particularly useful, because of their reaction to heat.

Colour mixing with these fabrics is achieved in the same way as colour mixing with paint: red and yellow combine to make orange; blue and yellow make green; red and blue make purple, and so on.

As well as using purchased fabrics, you can use waxes and oils to create your own sheer materials from ordinary fabrics and paper, as described on pages 24–29. By using your own creations on their own or in combination with bought fabrics, you can produce exciting and innovative surfaces that have reflective and translucent qualities.

Right: *Crossing Boundaries* by Linda Robinson. An embroidered 2-D hanging in which transparent layers are bonded together to create subtle colour blending. The cut-out windows are heavily embellished with stitch.

Colour mixing with sheers

Sheer fabrics allow you to blend colours and build up colour intensity by layering and mixing, in the same way that you would use watercolours and inks. The addition of threads will also influence the overall visual effect of colours, and varying the thicknesses and textures of thread will aid the blending of colour.

- Cut six 5cm (2in) strips, each about 25-30cm (10-12in) long, from about 10 single-colour chiffon scarves.
- Lay four strips together lengthwise, overlapping them (see the diagram below left).
- Using thread in either a contrasting or sympathetic colour, join the strips with running stitch.
- Continue to add and layer all but two of the remaining strips, to form a cloth.
- Now cut the remaining two strips in half and layer them horizontally across the newly formed fabric. Leave gaps between them to show variations in the colour, revealing the underlying layers and the build-up of colours (see the diagram below right).
- As before, work running stitches to combine the layers.
- Explore further colour blending with seeding stitches (short, straight stitches arranged closely at random).

Opposite: Colour mixing with sheer fabrics and thread. Strips of chiffon scarves and net layered and overlapped, then secured with running stitch using silk thread.

Below: Examples of layering sheer fabrics in strips, showing both vertical and horizontal overlays. Dotted lines denote stitch.

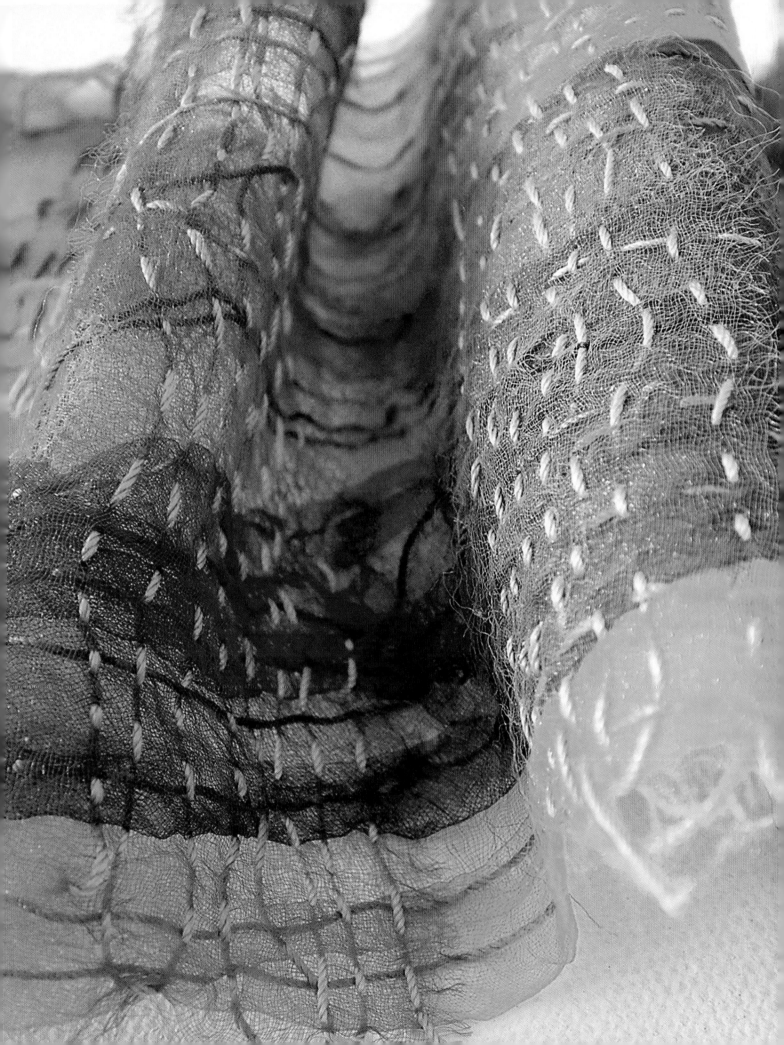

Above and right: Further ideas for layering and
combining sheer fabrics in an overall design.

Shadow techniques

Traditional shadow work is a technique that became popular during the eighteenth century for decorating clothes for special occasions such as bridal wear and christening gowns. It has continued to be popular and today is often worked on table linen and lingerie. The technique uses fine sheer fabrics such as cotton organdie, silk organza, fine silk and muslin. The design is worked in closed herringbone stitch on the wrong side of the fabric, producing a neat backstitch outline on the right side; the herringbone stitch is visible from the front of the fabric as a delicate shadow.

Below left: A shadow-work sample. Areas of one, two and three sheer fabric layers worked using traditional shadow-work stitches.

Below: another example of the traditional shadow-work technique, seen from the front (above) and the back (below).

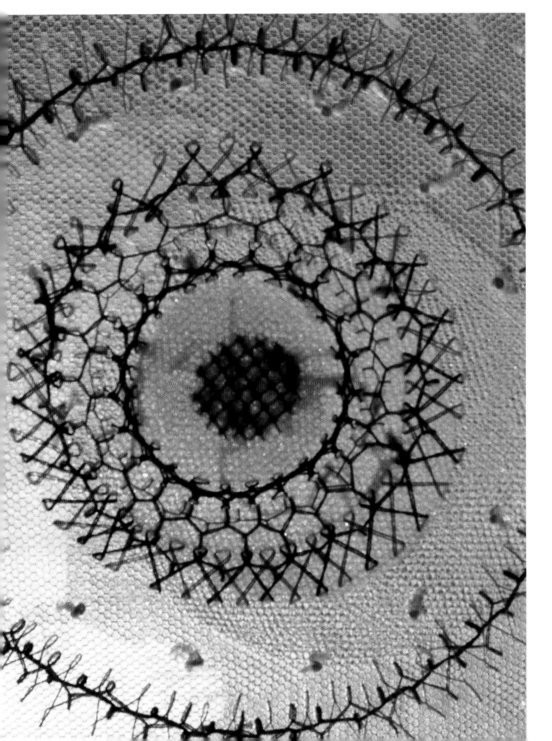

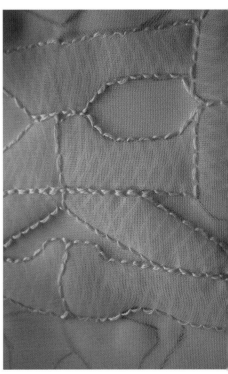

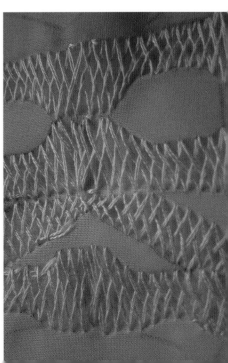

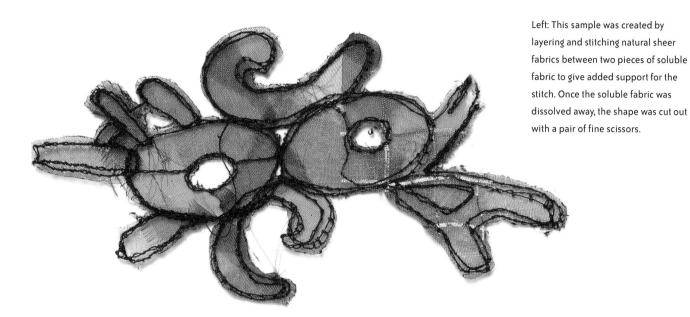

Left: This sample was created by layering and stitching natural sheer fabrics between two pieces of soluble fabric to give added support for the stitch. Once the soluble fabric was dissolved away, the shape was cut out with a pair of fine scissors.

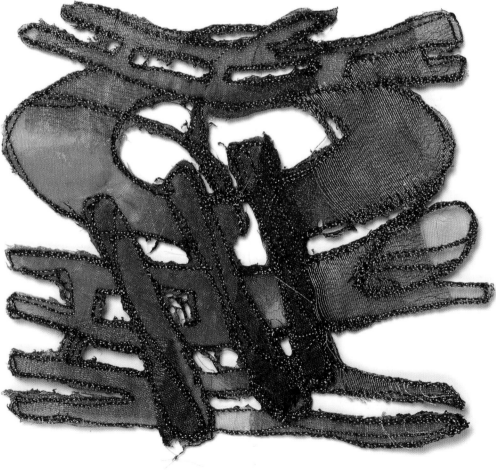

Left: A similar example, but this time synthetic sheers were layered and overlaid onto a single layer of a sheer base fabric. The whole thing was then placed in an embroidery hoop and the shape was machine stitched with straight and zigzag stitch. Finally, it was cut out using a soldering iron.

Bondaweb, bonding powder and FuseFX

Further methods of building up colour blending with sheers include using Bondaweb (Wonder Under) to bond the fabrics together. Bondaweb, FuseFX (a very fine heat-fusible fabric) and bonding powders can be used as they are, but care has to be taken as sometimes a gluey appearance can be seen through the sheer fabrics, which can be unsightly. To avoid this problem, Bondaweb and Fuse FX can be painted with watered-down acrylic paints and silk paints. This way, wonderful watery effects are achieved, which will enhance and add texture and further depth to the blending process.

The painted Bondaweb and FuseFX can be ironed onto the back of the fabric and shapes can be cut out, which can then be fixed by ironing onto a background fabric.

You can also tear strips and small pieces from painted Bondaweb or FuseFX. These fragments can then be positioned between layers of sheer fabrics to build up ethereal and soft-focus effects.

Once you are happy with the overall effect you have created, all you need to do is to place the sheer sandwich between two pieces of baking parchment and iron to fix.

An additional benefit to using Bondaweb and FuseFX is that the glue will give stability to the fabrics, making them quite firm. This in turn makes the resulting fabrics suitable for dimensional work.

Below: *Window Hanging* by Wendy Creak. Manipulated sheer fabrics with stitch create dimension across a hand-knitted surface.

Gathering, pleating and folding

Sheer fabrics lend themselves particularly well to being manipulated, as they do not create much bulk when worked. Interesting dimensional effects occur as the folds and gathers undulate across the surface.

A particularly fine sheer fabric can sometimes be hardly noticeable. This problem can be overcome by pleating, gathering and so on, to give more substance and structure, as well as interest, to the overall surface.

Sheers that are synthetic have a much springier handle to them when manipulated, when compared with sheers made from natural fibres, which have a crisp, firm look, particularly when folded or pleated. These varying effects can be put to full use when producing work that requires dimension and form. Exploring and exploiting these qualities will provide you with an unending supply of source material to draw upon when creating work. Try the following:

- Folds or pleats on the cross
- Gathering
- Pleating
- Stretching

Below: Three possible ways to fold and manipulate fabrics. Left: Pleating with machine stitch across the grain (bias) of the fabric. Middle: Wires, sticks or lengths of dowel can be threaded through the channels of the pleats. Right: When using wires you can bend and manipulate the work into shapes. Decorate the ends of the wire with beads.

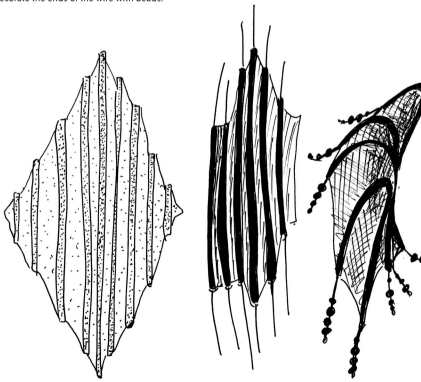

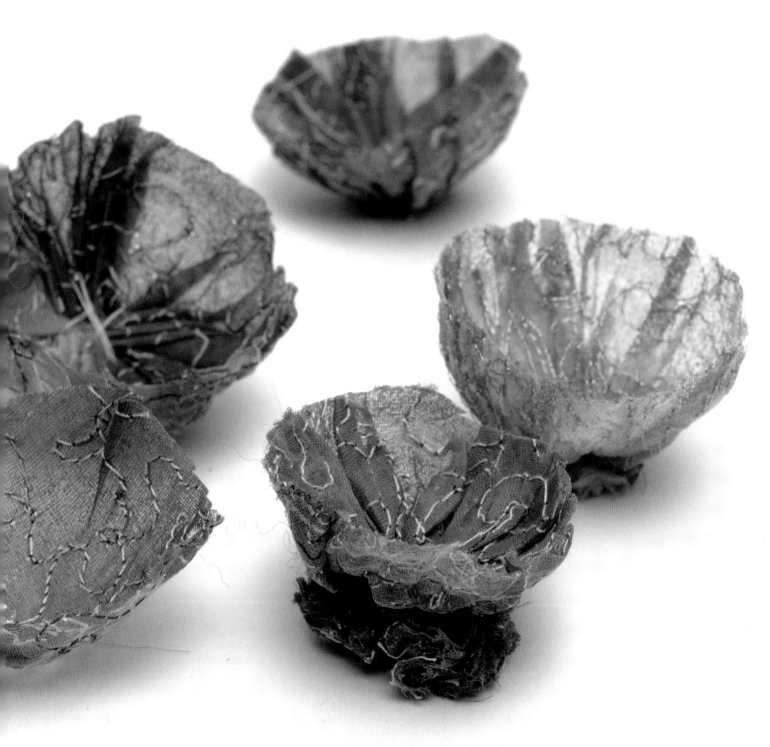

Above: These cup-shaped rosettes were made from a bonded sandwich of chiffon scarves, with fabric and thread snippets trapped between the layers, and secured with machine stitch. To make each rosette, a large circle was cut out and tied around a ball, then the shape was heat-fixed with steam. A soldering iron was then used to cut the shape in half, making two rosettes.

Waxing fabrics

When wax is added to the surface of a fabric, the quality of that fabric changes. What may have been a fairly non-transparent material suddenly takes on wonderfully subtle, translucent properties. Altering fabrics in this way gives an additional source of materials with which to work. In addition to the translucent effects you get when waxing fabrics, the addition of wax also gives a firmer finish to the fabric, making it ideal for structures and sculptural forms. The wax will also give a wonderful handle, especially when stitch is added after the waxing process.

Using stitch, before or after or both, will also give rise to variations in the way the fabric surface is affected.

Right: Cotton muslin dyed with yellow Procion dye, then brushed with wax to create a resist design. The fabric was then overdyed by directly painting onto the surface of the muslin to give a colour-washed effect.

Below: Soluble lace thee-dimensional embroidery coated with a layer of wax.

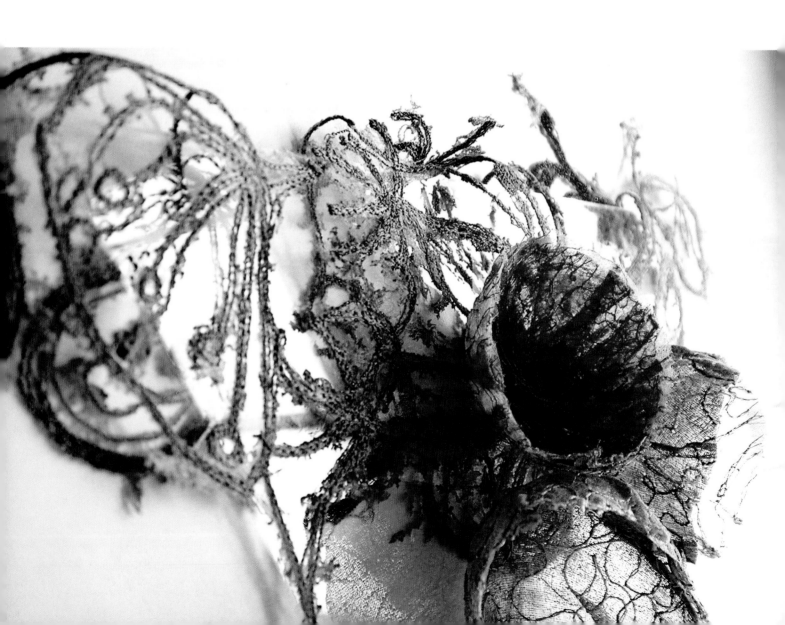

Applying wax

Wax has been used for centuries to create defined patterns on cloth by means of a resist, as in batik, but a completely different effect is achieved when you apply wax all over a fabric. The range of effects can be further extended by applying wax in sections to vary the amount of translucency, adding contrast and texture.

- Begin by placing a rectangle of fabric on a piece of fairly thick plastic or glass.
- Taking a wax pot and some candle wax, heat the wax up to 60°C. The wax will become completely clear when it has reached the correct temperature.
- Taking a brush (always keep wax brushes just for wax), dip the tip into the melted wax and apply wax all over the surface of the fabric. Instantly, you will see the cloth change in appearance as it immediately becomes translucent. If, when you apply the wax, the wax is opaque, with a whitish tint, then it is not hot enough and will sit on the surface. Turn the temperature control up slightly to obtain clear wax.
- Once the fabric is waxed, carefully remove it from the glass or plastic surface. Take care, as the fabric may still be hot.
- To remove excess wax, place the waxed fabric between two pieces of absorbent paper – blotting or cartridge paper, or even some more fabric, will do the trick. Heat a flat iron to a wool setting and iron the fabric-and-paper sandwich. Any excess wax will be taken up by the absorbent paper or fabric. The heat will also allow the wax to flow into any areas that have not been completely covered in wax, ensuring a more even covering.

Once the fabric has cooled, you can use it as you would any other fabric, stitching into it by hand and machine.

Left: To make this sample, a monoprint on tissue paper was placed between two layers of cotton organdie. The whole piece was then waxed and ironed, and machine stitch was used to highlight the design.

Further techniques with wax

You might like to try the following experiment:

- Take two pieces of organdie. Place another fabric between the organdies to make a sandwich, and then apply wax in brushstrokes over the surface. The wax will bond the layers together.
- Place the layers between two pieces of absorbent paper and iron the sandwich. The wax will melt further into and through the layers, any excess being picked up on the surface of the papers.
- Peel away the paper and leave the bonded layers to cool.

The wax will have given the fabrics an added dimension by adding a firmness to the surface. You can also trap papers as well as fabrics, fibres and thread in this manner. If you print or stencil a design onto the sandwich fabric, and this is then sandwiched between transparent fabrics, the sheer fabric will soften the design. A design can be reinforced by adding additional detail with stitch lines, made either by hand or machine.

Below: In this sample, a piece of silk organza has been placed over the top of a sheet of tissue paper printed with a stamp and decorated with cut-fabric shapes. The sample was then waxed and ironed, and the design was outlined with machine stitch.

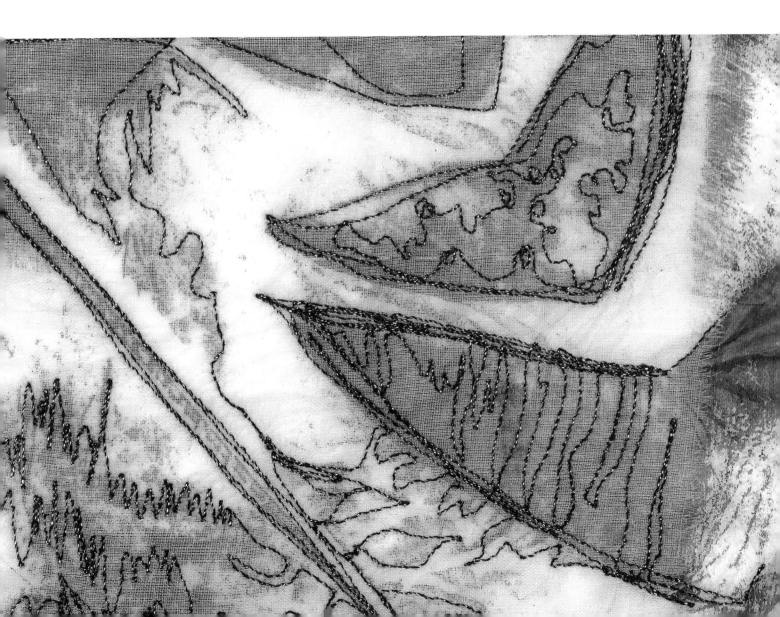

Waxing or oiling paper

Tissue paper, glassine, drafting film and tracing paper offer a further range for exploring transparency. They are also invaluable when it comes to designing, as they suggest a degree of the translucent effect that you will be able to achieve, helping you to visualize how your work will ultimately look. Incorporating and combining treated papers with fabrics will add further interest and variety to finished pieces of work.

Again, adding wax to normal papers can transform them from opaque to translucent, and papers can also benefit from having oil washed over their surface. Sometimes the level of translucency is immediately apparent, but sometimes it is only apparent when you place a light source behind it.

You can add wax to papers in much the same way as to fabric: simply heat the wax as described above, for fabrics, and apply it to the surface.

You will notice that as soon as the wax is applied, the paper becomes translucent – a quality that encourages creative exploration, particularly if you add to the effects by using a light source.

You can also get similar results by rubbing the surface of the paper with wax crayons, and then ironing it between protective layers.

Below: For this sample, molten wax was dripped over the surface of rag paper, then Procion dyes were painted and sprayed onto the surface.

Oils will give a similar appearance to the surface and will again render a paper translucent. Any oil will do, but artist's linseed oil is generally the preferred choice, as it leaves a less greasy residue than most oils. However, vegetable oils and even baby oil will also work, and baby oil has the benefit of smelling nice.

To oil a paper, make a wad of muslin and use this to dab the oil onto the paper, gently working the oil over the surface.

Another way to change the surface is to cover the paper completely with graphite and then add the oil. The oil will push the fine particles of graphite in and around the top of the paper, at the same time giving it a lovely grey tone. This works particularly well on brown paper. You can generate further interest by scrunching the paper first before applying either wax or oil. Lightly rubbing the surface over with emulsion, gesso or acrylic also gives a rather nice effect, as this will pick up the relief surface of the scrunched paper.

Stitches can be worked on the paper surface, either by hand or machine methods. Use stitch marks to define some sections, link and unite areas of interest or to add details or texture to the surface. Think of the stitch as a way of mark-making, rather than as more decorative embellishment.

Above: A selection of samples made on basic photocopier paper, using wax as a resist and coloured with Brusho paints. Once this was dry, wax was applied over the whole of the surface and ironed off, giving a level of translucency even on the coloured areas.

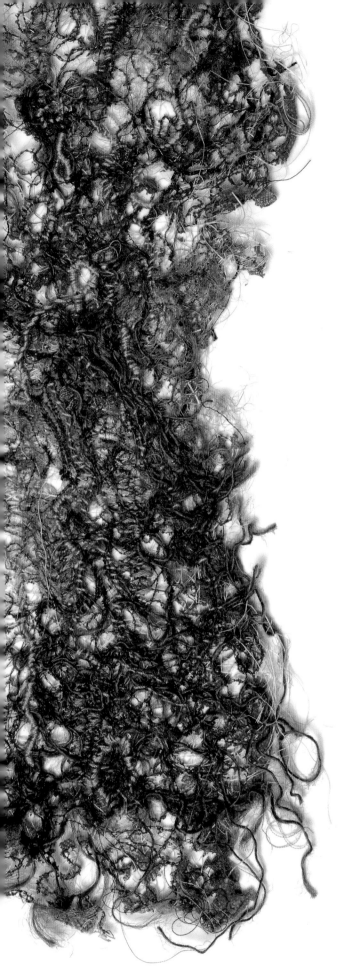

Solubles and non-wovens

Although not truly transparent or offering translucent qualities, soluble and non-woven fabrics can be adapted to offer exciting translucent dimensions. Stitched grids, open networks and structures will create areas that can be looked through to reveal layers beneath the surface, giving the illusion of transparency.

Solubles

Soluble fabrics come in a number of guises: some are clear, being similar to clingfilm (Saran Wrap), while others are more fabric-like in their feel and handle. The benefit of using the clear films, perhaps obviously, is that you can see through them. Often, you will find you have a preference for one or the other, but remember that sometimes a particular type may be more suited to a specific application. Clear solubles include Romeo, Giulietta and Aquafilm. These dissolve in hand-hot or cool water. The only problem I find is that they are very gloopy when they are being rinsed.

Fabric types include Solusheet, Solufleece and Aquabond water-soluble fabric, which has an adhesive layer. You can place the Solusheet or Solufleece over your design and trace directly onto the soluble fabric, using a pencil or ballpoint pen, and you can do the same with the Aquabond fabric or even inkjet print directly onto it.

If you take a soluble fabric, colour it, layer it and then partly burn it away, it will obscure some of the design or pattern on the previous layer. It can also help soften a hard design, and will even alter the colour balance. For instance, if you have a red fabric and you place a yellow open soluble fabric over the top, your eyes begin to perceive an orange tint on the surface.

Burning techniques can also be used with non-woven fabrics such as Lutradur, to reveal layers below. When the background fabric is required to remain intact, you should always make sure that it is made from natural fibres, such as cotton, linen, viscose or silk. The non-woven or synthetic fabric reacts to the heat, but the natural fabric does not. If both fabrics were synthetic, then both would be burned away, giving a different look.

Left: This eroded textile was created by stitching onto horticultural fleece that had been coloured with watered-down acrylic paint. The piece was then blasted with a heat gun and additional fibres were added with hand stitch.

Opposite page: Lutradur fabric (70gm weight) was painted with acrylic and machine stitched to a backing fabric of Procion-dyed organdie. The patch was then blasted with a heat gun to reveal the layer underneath. The solid areas of the Lutradur that remain contrast with the areas of sheer fabric beneath.

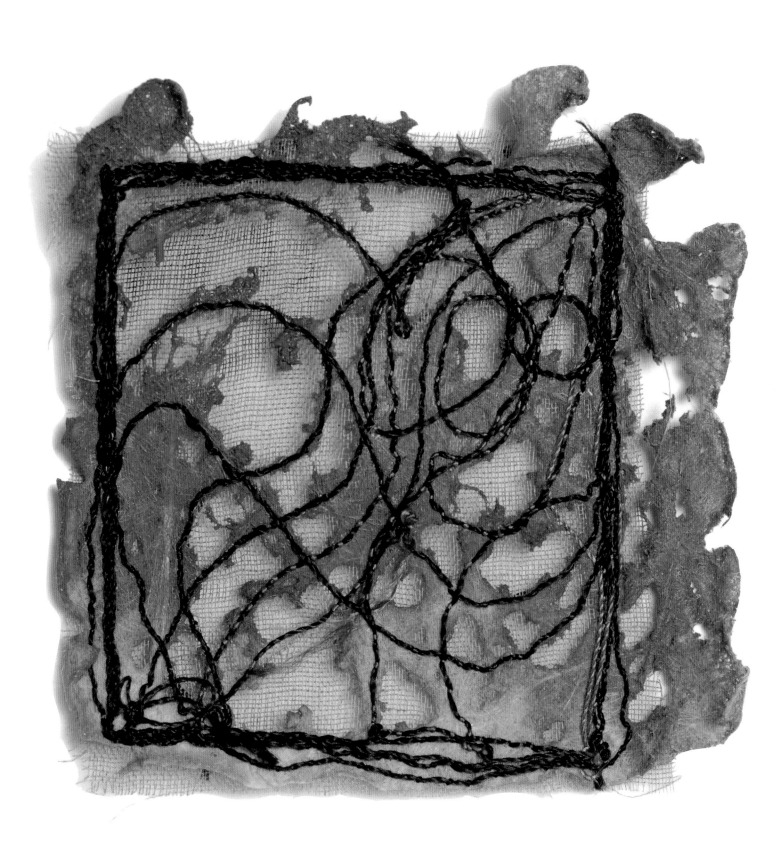

Non-wovens

These products are predominantly synthetic. They do not have any weave structure, as the fibres are pressed, bonded and fused together.

The products that have the most translucent qualities when worked are Sizoflor, horticultural fleece and Lutradur – particularly the lightweight type. Lutradur comes in a range of weights – 30gm, 70gm, 100gm and 130gm – and each of these can be coloured in the same way and react in the same way when heat is applied. The 30gm weight has a very delicate, filmy quality and is best used when a translucent overlay is required, or if you want virtually all of the Lutradur to be removed after stitching – almost as if you are using it as a support while working the embroidery on another fabric. When used in this way, Lutradur has an advantage over solubles due to its melting quality – when blasted with heat, the fibres melt, fuse and bond together, making it unnecessary to work a machine-stitch grid to hold the stitch in place. Evolon, horticultural fleece and Sizoflor give similar effects: experimenting with the different types and weights will help to familiarize yourself with the individual products and how far you can incorporate them into your work. Making notes on the individual materials in a workbook as you explore their properties can be a very useful practice.

Below: Lutradur fabric coloured with acrylic paint and machine stitched with Lana thread, shown before and after using a heat tool. Note how the treated fabric allows a transparent effect to be achieved.

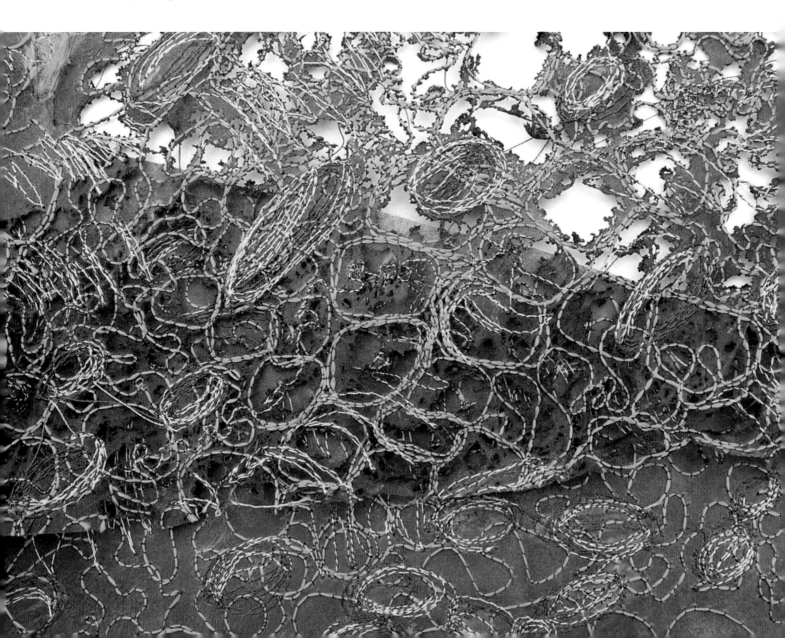

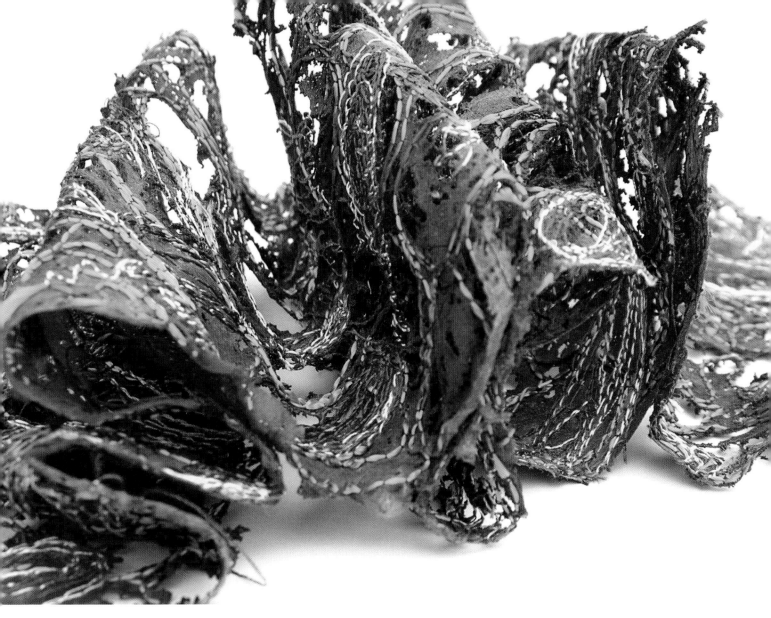

The great advantage of working with non-wovens is that they react to heat, which allows you to use design effects created by distortion. You can also use a soldering iron to create incised marks and to cut out shapes, and even burn the edges with incense sticks to add a rather lovely singed colour.

Non-wovens can also be coloured. You need to use disperse dyes or transfer paints, which are designed to be used with synthetic fibres. To use disperse dyes, you will first need to mix them with water, making sure the powder is fully dissolved before use. Transfer paints come ready mixed, so you can use them straight from the jar. You can also mix the paints. Another option is transfer crayons, which come in a limited colour palette. To use transfer colours, you will need some typing paper or printer paper.

- Paint, print or stencil a design onto the paper with transfer paints or crayons.
- Leave the paper to dry.
- Place the dry paper design side down on the non-woven (or indeed any synthetic) fabric. Place a piece of baking parchment over the top and, using a wool setting, lightly run the iron over the top. Be careful, as the fabrics react to heat and may distort and bubble, or even disappear.

The only fabric that you cannot colour in this way is horticultural fleece, since it reacts so severely to the heat of the iron that it will disappear without trace. You can, however,

Above: Exciting dimensional possibilities can be created by manipulating the fabric to give an undulating surface. The open network lets the various layers become visible, giving you glimpses and different perceptions of the design as you look through.

colour the fleece with acrylic paints or fabric paints, and you can use the same paints on Sizoflor and Lutradur.

Once coloured, these fabrics can be stitched. They will allow light through as they are, but, when zapped with heat, areas where there is no stitching will erode and burn away while the stitching acts as a resist and will remain intact.

The resulting fabrics can be used in the same way as soluble fabrics, allowing light to filter through from one layer to the next. They will also cast interesting shadows across a wall when placed a little way in front of it.

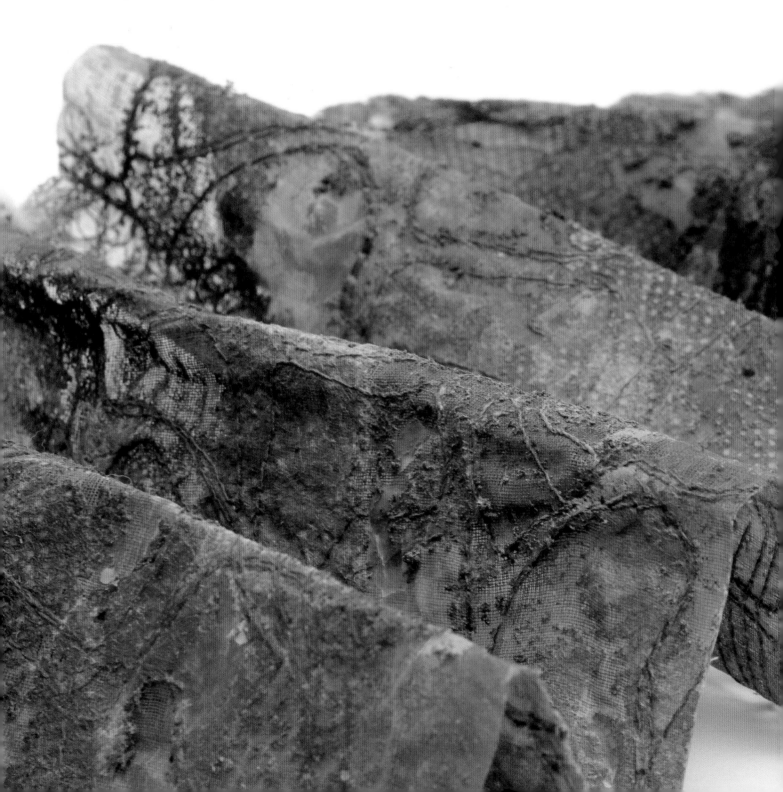

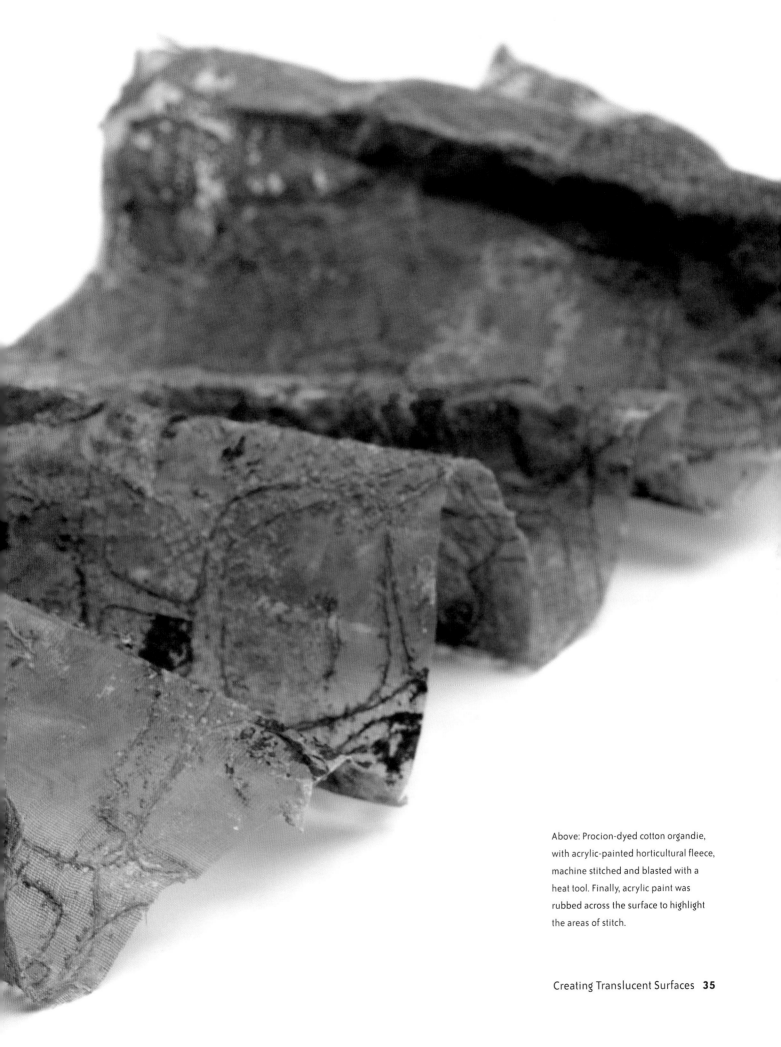

Above: Procion-dyed cotton organdie, with acrylic-painted horticultural fleece, machine stitched and blasted with a heat tool. Finally, acrylic paint was rubbed across the surface to highlight the areas of stitch.

Fibre, thread and stitch

When you take a single thread on its own, it can seem uninspiring and slightly insignificant, but when woven or knitted together with others, wonderful and amazing structures and fabrics can be created – all starting from a single thread.

The vast number of possible techniques offers a wide range of finishes and surfaces that can be used in numerous ways to produce form and dimension, as well as a basic two-dimensional fabric.

Take an ordinary embroidery thread that has been made into a woven fabric, using a simple card or wood frame. Keeping the warp and weft taut and even will result in a uniform all-over weave. If you repeat the exercise, this time weaving much more loosely, the resulting fabric with have an uneven finish.

Left: Drawings showing the effects that can be achieved by varying the weave, either through manipulation or by overlaying different open weaves on top of each other.

Right: In this piece, natural jute scrim has been distorted with machine stitch.

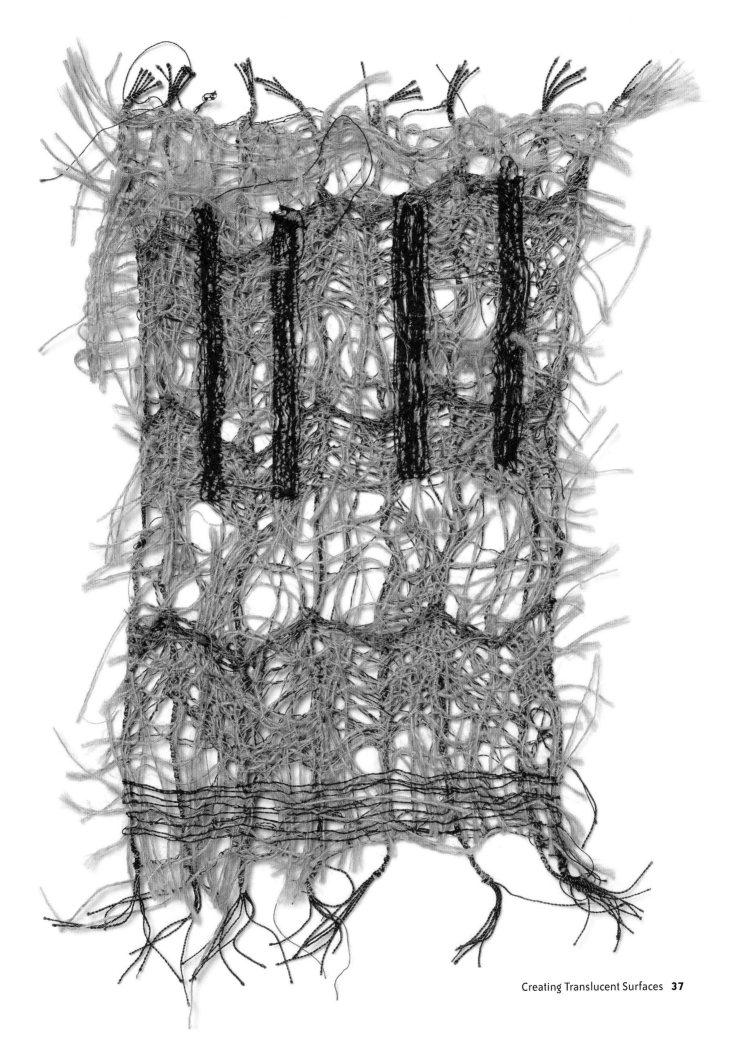

Try the following exercise:
- Produce three handwoven fabrics, but alter the thread used, vary the tension of the weaving process and change the position of the warps.
- Make notes of how the results appear visually different.
- Hold them up to a light source and notice how they obscure the image beyond and how they differ from each other. What they are also doing is producing a level of translucency: a closely woven fabric will allow much less light through, compared to a more open-weave fabric.
- If you place one in front of the other or overlap just a small strip, further combinations will show themselves.
- Try distorting the weave by manipulating the warp and weft threads to create large open areas, followed by densely packed ones.

Playing around with these fabrics should inspire further ideas for transparency. As well as weaving threads, you can produce knitting, knotted and crocheted fabrics to offer a wealth of textures and surfaces that can be used in similar ways.

Below and right: Machine-made grids of jute fibre and cords, woven into by hand and stiffened with resin.

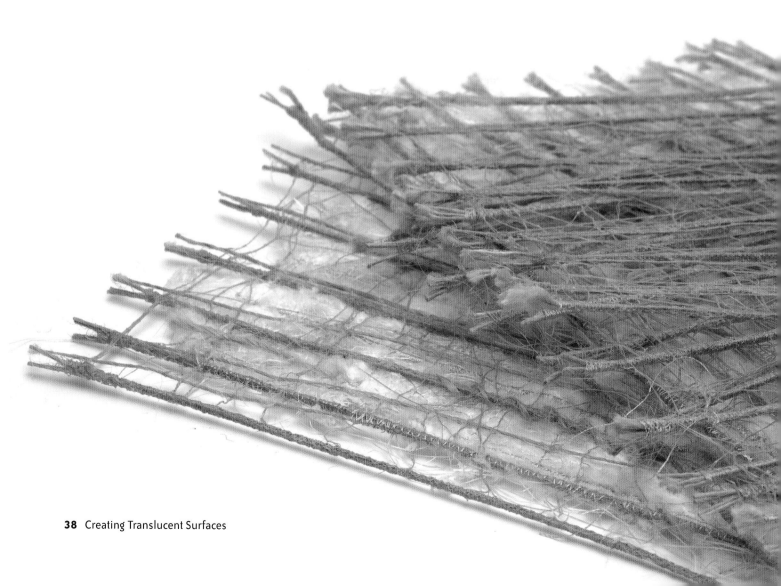

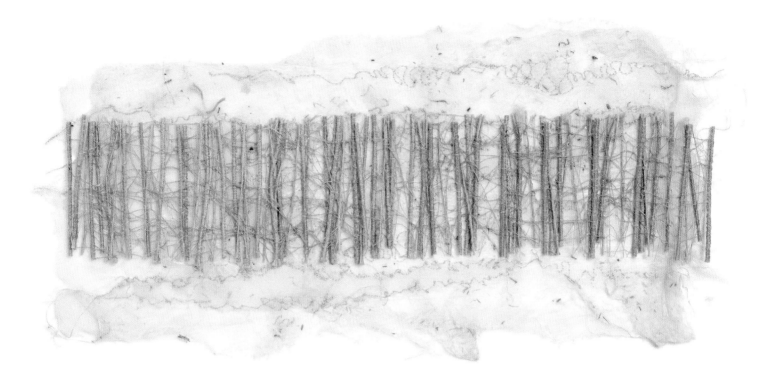

Fibres

Fibres are wonderful when used sparingly to produce sheer see-through fabrics and papers. (The less fibre that is used to construct a fabric, the more transparent it appears.) They give a subtle quality when overlaid on top of other work, and they can also be manipulated to produce form and structure, either on their own or when a stiffening medium is used. Even when rigid, they can retain a certain delicacy.

SILK FIBRES

There is a wide range of silk fibres on the market. The one important aspect you need to consider when selecting silk fibres to produce silk fabrics and papers is whether or not the fibres still contain the natural gum. This gum is known as sericin, and is removed during most of the processes that are used to get the wonderful lustrous silk tops with which we are familiar.

If you purchase silk fibres, you will note that the word de-gummed is often written on the label, which means that they have had the natural gum removed. Unfortunately, the only way in which you can create silk paper or fabric with these fibres is to re-introduce some type of glue.

However, the silk fibres known as cocoon strippings still retain the natural sericin, and heat and water are all you need to activate it.

MAKING SILK PAPER

To make a simple silk paper, you will need:

- Cocoon strippings (these are matt fibres, short in length, which look a little bit like scraps of cotton wool)
- Water spray
- Iron
- Ironing board
- Baking parchment

Method:

- Take a handful of strippings; gently tease the fibres out and lay them on top of some baking parchment, covering an area approximately A4 (letterhead) in size. Be sure to have a thin, wispy layer.
- Using a fine water spray, cover the fibres to make them damp. Do not saturate: you are aiming for a light mist.
- Place another sheet of baking parchment on top, so you have a sandwich of baking parchment, damp fibre and baking parchment.
- Heat your iron to the wool setting; place the sandwich on the ironing board and gently iron across the top of the parchment, keeping the iron moving.
- Turn the sandwich over and iron the other side. The steam that is produced from the heat and water activates the natural glue in the fibre, bonding them together to produce a fabric.
- When you have finished ironing, leave the sandwich to cool slightly, and then peel away the sheets of baking parchment. You will be left with a fine fabric that can then be used in any way – manipulated, stitched, cut, applied to another fabric and so on.

The above method can be varied with the addition of other fibres, threads and snippets of fabrics, adding further interest and texture to the surface. Trap the additional materials between the layers or add them on top in an all-over design or pattern.

Fabric shapes can be partially hidden between fibres, with the remaining part of the shape resting on top, to give an in-and-out-of-focus effect. Placing fibres over fabrics gives a shadowy feel.

The resulting fabric/paper can be pleated then placed between a baking parchment sandwich and ironed. When you peel away the baking parchment, you will be left with a pleated fabric that can be applied to a surface. Alternatively, you can repeat the process and join the sheets to form a structure.

Silk fibres can be laid onto a fine fabric to give additional firmness. Natural fabrics, such as silk, cotton or linen, are more suitable for this technique. A sandwich is made, as before (do not forget to spray the fibres and fabric with water). The sandwich is then ironed and the outer layers removed in the same way. The glue in the fibres will bond with the backing fabric, to give yet another type of surface.

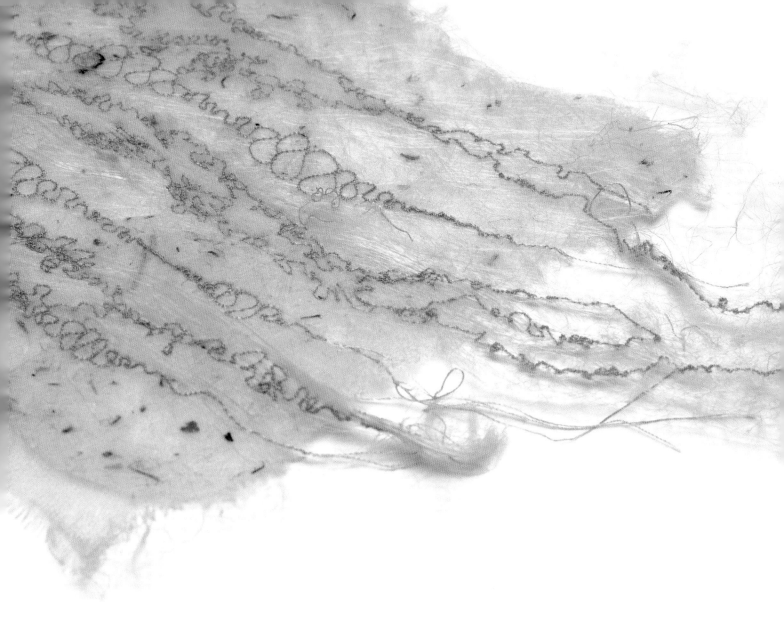

COLOURING

Although you can purchase ready-dyed silk fibres, undyed fibres give you scope to add the colour yourself. The simplest, quickest and easiest method is to use silk paints.

You can paint these directly onto the made paper/fabric with an artist's brush. Alternatively, pour the silk paints into a spray bottle or mister and spray the colour on. Using a spray to apply the colour will enable you to build up the depth of colour gradually and will lessen any hard lines. It will also give subtle colour-blending across the surface.

Above: This delicate translucent fabric was created using cocoon strippings, strips of silk mousseline and machine stitch.

WOOL FIBRES

Wool fibres naturally bond together when heat, water and friction are applied to them. The fibres themselves are covered with tiny barbs along each length and, when the fibres are agitated, they therefore tangle together to form a cloth.

Most of us have used wool fibres to make felt that is relatively thick and dense, but cobwebby, soft, delicate fabrics can be made with a minimal amount of fibre, and these are almost transparent.

Adding wool fibres to fine fabrics, such as muslins, scrims or silk chiffons, will produce soft, flowing and sheer fabrics.

Wool tops come in a wonderful array of seductive colours as well as a variety of undyed natural colours in cream, grey, beige and brown.

Unlike silk fibres, wool requires the use of natural or acid dyes and steaming or boiling, which is more labour-intensive. It can be difficult to produce the depth of colour that you get from pre-dyed purchased wool tops. In this instance, buying ready-coloured tops is preferable. You can still blend fibres together to create other colour blends.

Although I am not going to go into the subject of feltmaking in detail, I do, however, feel that a couple of feltmaking techniques lend themselves very nicely to the creation of transparent effects. These two methods will therefore be covered here briefly.

Above: A fine, delicate felt explores transparent qualities. The open strip and pocket were created using the resist technique, allowing levels of light transmission. Sample by Hazel Cilia.

Below: If you apply thin layers of fibres you can create the suggestion of transparency as underlying layers can still be seen.

COBWEB OR LACY FELT

To make cobweb felt, you will need:
- 25–50g (1–2oz) of wool tops (dyed or undyed)
- Two pieces of synthetic net-curtain fabric
- Straw beach mat or two sheets of bubble wrap
- Rolling pin, covered in clingfilm (Saran Wrap)
- Old towel
- Soap flakes
- Water
- Spray bottle

Method:
- Place one sheet of your bubble wrap or your mat on top of the towel.
- Place the synthetic net on top of this.
- Take the wool tops and tease out a handful of fibres.
- Lay the fibres down vertically on the net in such a fine layer that you can hardly see them. Repeat, but this time lay the fibres horizontally across, to give a second layer. Remember to keep the fibres so fine you hardly notice them.
- For the third layer, lay them across vertically again. You should have three extremely fine layers, running in alternate directions. You must be able to see through the layers.
- Cover with the remaining piece of net.
- Dissolve some soap flakes in water and transfer the solution to the spray bottle.
- Spray the fleece fibres through the net with the water and soap. Make sure they are fully wetted and pat them down with your hands to make sure all the water has got through. The whole surface must be wet, but not saturated.
- Next, cover with the bubble wrap or, if using a mat, fold this over the top.
- Place the rolling pin at the end nearest to you and begin to roll up all the layers.
- Keep rolling back and forth as though you are rolling out dough.
- You need to keep doing this for between 10 and 15 minutes.
- Unroll and pull out any creases that may have formed. Roll up and repeat the rolling process for another 10 to 15 minutes.
- Unroll again; turn the layers over, and then roll and repeat.
- Next, remove the bubble wrap or mat and take the sandwich of fleece and net over to a sink.
- Pour hot water over it and gently squeeze out the excess.
- Flatten out the sandwich and carefully remove the felted fibres from the net. You should have a very fine but robust fabric that you can see through.

The resulting fabric can be combined with others, stitched and manipulated.

Above: An open network made using
soluble fabric, with very fine wisps of
merino wool fibres applied to both sides.

APPLYING FIBRES TO FABRICS

You can add fibres to fabrics and felt them to create interesting textures. As the fibres shrink in the felting process, the supporting fabric becomes distorted. For this technique, you need to use fabrics made from natural fibres, such as cottons, linens and silk chiffons. This type of applied felting is known as nuno felt.

NUNO FELT ON FINE FABRICS

You will need:

- Bubble wrap or mat
- Net
- Towel
- Wool fibres
- Silk chiffon
- Rolling pin

Method:

- Lay your bubble wrap on top of the towel.
- Next, place the silk chiffon on the bubble wrap. Gently tease out some wool fibres and place them in a grid pattern over the surface. Leave about a 7.5cm (3in) space between the grid lines and leave the spaces between the lines empty.
- Cover with a piece of net and spray with water as before.
- Finally, cover with the bubble wrap or mat and begin the rolling process.
- Repeat and turn the layers over several times, rolling at each stage.
- Once the fibres have started to felt and shrink, remove the bubble wrap and peel away the net.
- Pick up the fabric and notice how much the fabric between the grid lines of fleece has shrunk. It should be starting to wrinkle.
- Start throwing the fabric onto the work surface like a piece of dough. This will encourage the shrinking process and help push the fibres through the fabric.
- When it has shrunk and felted to the desired effect, take it to the sink; rinse, pat and leave to dry.

You can experiment with placing the fibres in different ways. Also, try using cotton scrim or muslin instead of silk chiffon, making notes of the different effects that can be achieved. You can also apply fleece to both sides of the supporting fabric.

The more you explore and experiment with different techniques, the more familiar you become with the ways in which fabrics, fibres and threads react.

Opposite: In this piece of Nuno felt, wool fibres were added to both sides of cotton scrim in a grid pattern.

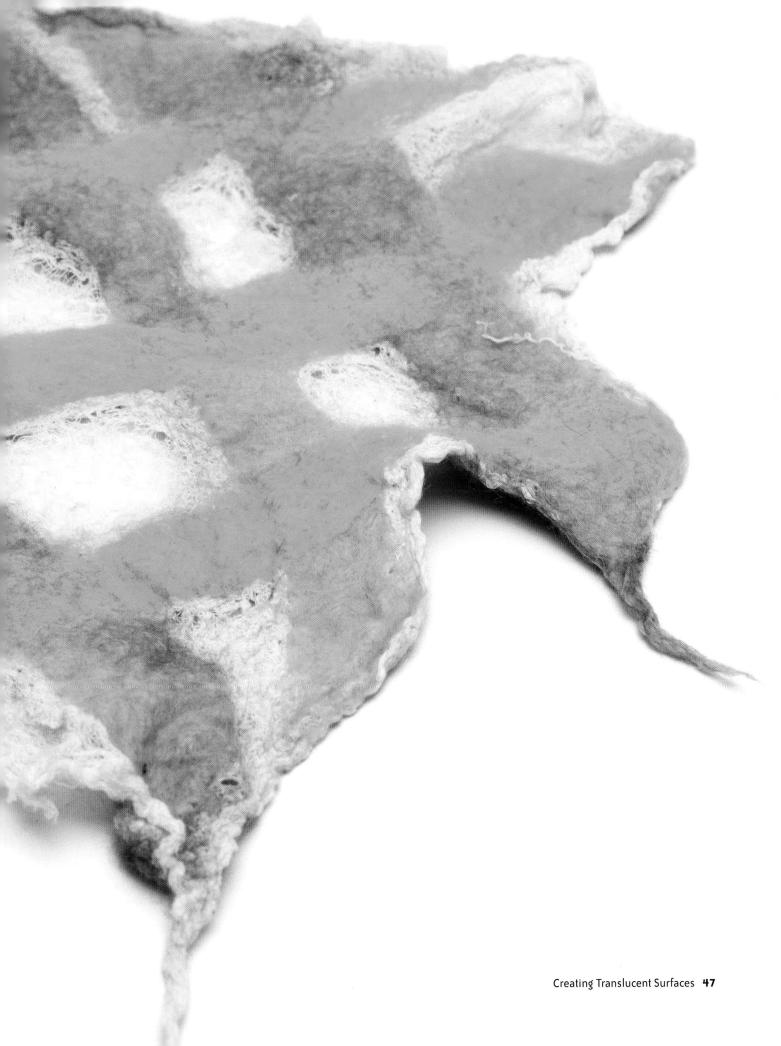

Stitch

Stitch is the element that pulls everything together. The types of threads selected, the colours, textures and so on all combine to embellish, link, join and enhance the papers and fabrics you work with.

Stitch can be used to create raised surfaces, join fabrics together, add details or become the design itself.

In addition to traditional stitch patterns, you can use threads and the process of stitching to create marks, in the same way as you would make a brushstroke. This opens up all manner of possibilities, especially when you look at the array of threads now readily available.

Consider the stitched mark as another art tool, a way of adding colour and fine detail to a design or composition.

Adding stitch to a sheer fabric will alter its translucent qualities. The more stitch marks you add, the less sheer it becomes. Exploring this aspect through a range of samples will enable you to become familiar with how stitching on lightweight and sheer fabrics changes the way light passes through them.

Below: This densely stitched and textured sample was made on cotton scrim. Even though this was heavily embellished, areas of transparency are still achieved.

Right: 'Crossing Boundaries' by Linda Robinson. Detail of embroidered 'windows' showing the intricate stitch used to fill in the open areas.

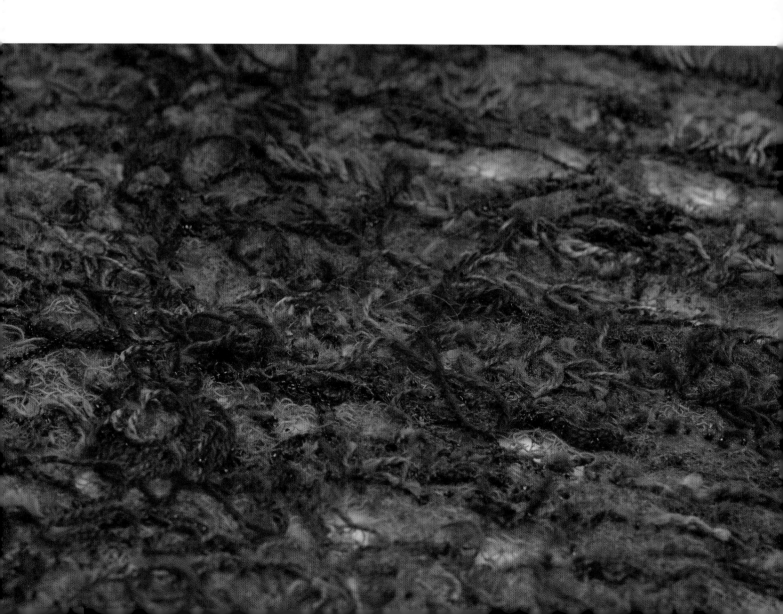

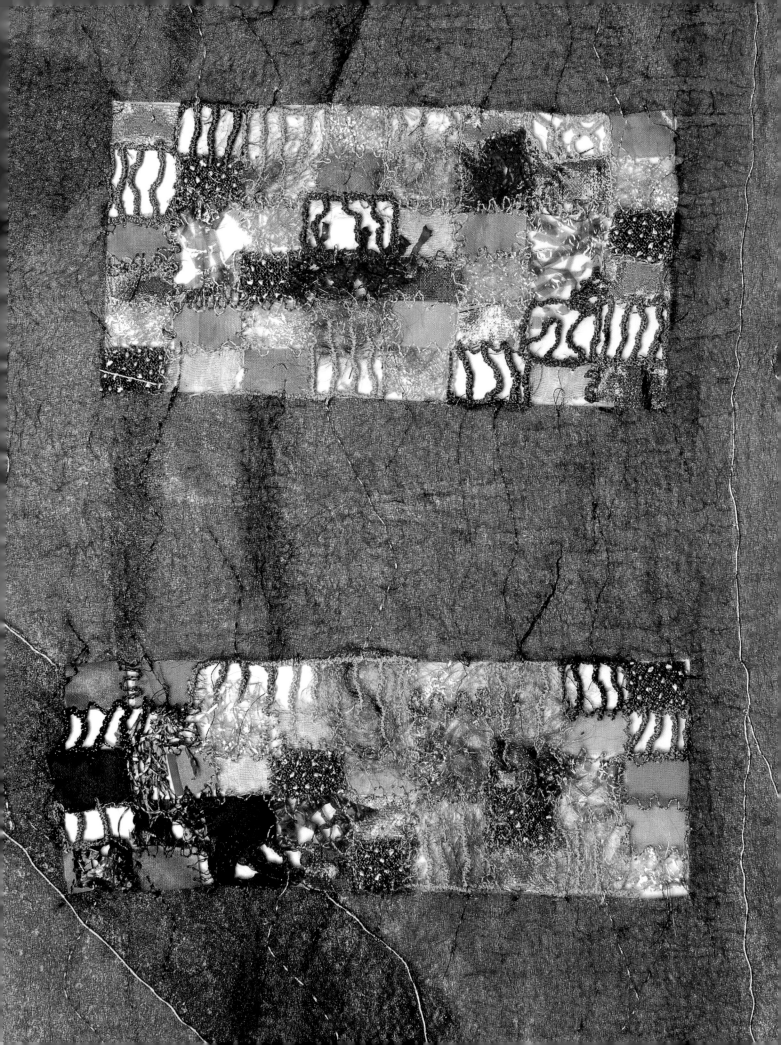

A SIMPLE STITCH EXERCISE

You will need:

- A 10 x 30cm (4 x 12in) strip of sheer fabric, neutral in colour
- A range of thread thicknesses, from machine thread to thicker wools, also neutral in colour
- Needles
- Scissors
- Embroidery frame

Method:

- Take the strip of fabric and divide it up into strips approx 2.5cm (1in) in width. (You can use basting stitches or lightly draw with a pencil.)
- Place the fabric in an embroidery frame, if you wish, and, starting with the thinnest thread, work seed stitches inside one of the strips.
- Miss the next strip and work the same seed stitch into the following strip, but this time use a thicker thread.
- Repeat along the length of fabric, each time missing a strip and then working with a thicker thread than the one used before (see the diagram below). You will see how the stitch and thread thickness changes the transparent effect of the sheer fabric.
- Try the same exercise again, but instead of using seed stitch, make long linear stitches, which will look very different. Other stitches and marks, either worked on their own or combined, will give a whole range of effects to add to your vocabulary.

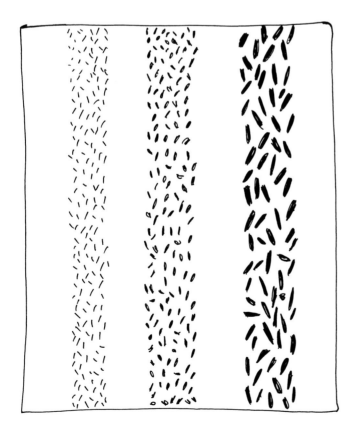

Right: Sample showing the effect of working seed stitches in different thread thicknesses on sheer fabric. Note how both the thread on the surface and that underneath are visible.

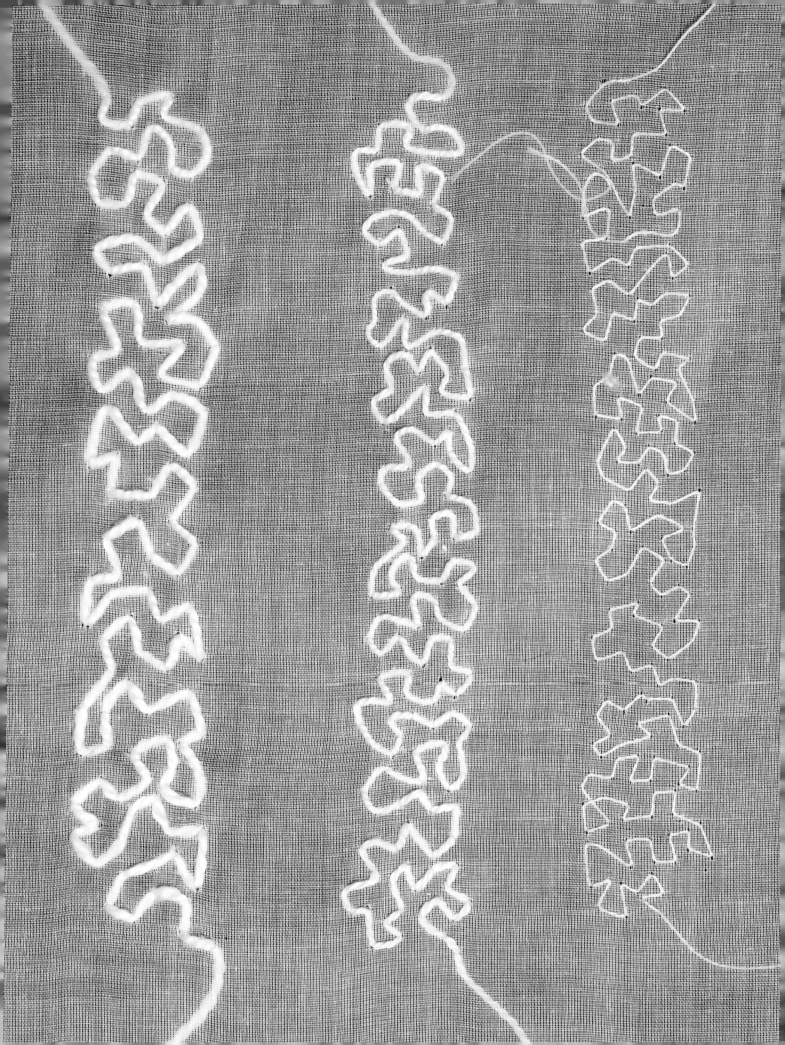

3 Using Transparent Materials

In this chapter, we will look at the range and variety of transparent materials that are available. This includes clear plastics and films, such as acetates, photographic film and cellophanes, together with the harder materials of acrylic and perspex sheet. A wide range of finishes offers further potential.

In addition, you can alter and manipulate the surfaces to create dimension, form and structure. The surfaces themselves are such that they allow you to incorporate personal imagery, through image transfer, print methods and surface treatment.

The other products that offer exciting possibilities for the textile artist are the polymer resins and gels with which you can paint, cover and coat your work, changing the appearance and potential of the textile. Alternatively, with the aid of moulds and formers, found objects and stitched textile pieces can be imbedded into crystal-clear transparent blocks.

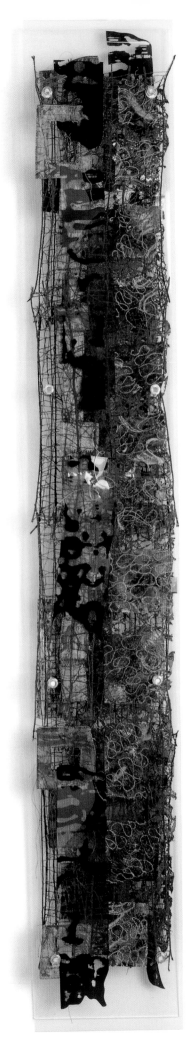

Above: *Essences of Summer* by Kathleen Laurel Sage, from a collection of seasonal clothing with matching bags made from PVC plastic with trapped organzas and free-machine stitching. Artwork and photograph by Kathleen Laurel Sage.

Right: A mixed-media work using layers of machine-stitched grids, photography, acetate film and resin. The layers make use of the transparent qualities of the individual elements. From the *Deep Water* series by Dawn Thorne.

Acetates and films

There is a wide array of purpose-made transparent films around, all of which are easily obtainable from selected suppliers. You can also find many films that are suitable to incorporate into your work in and around the home, including packaging materials, negatives from film cameras, the cellophanes that your flowers are wrapped in, birthday-card wrappers, old video-tape film and so on.

Some of these materials are more delicate and need more careful handling than others; all, however, can be stitched into, using hand or machine methods. Clear films offer glassy overlays when applied directly onto the surface of your work. Coloured films will give subtle colour-blending options, particularly when layered and built up. When using the firmer films, such as acetate and transparencies, further potential arises in the ability of the material to hold its own shape and weight, allowing for dimensional work.

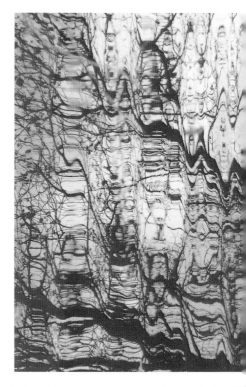

Using acetate sheets

Acetate sheets can be purchased easily from stationers and photocopy shops as well as specialist suppliers.

They do vary as to which application you use them for, such as photocopiers or inkjet or laserjet printers or for use with overhead projectors. Just remember this when purchasing them.

Printing

One method of adding design or imagery to your acetate sheet is to print onto it digitally using your computer or laptop. This can take the form of photographs or your own scanned art and design work. Utilizing any of the paint programmes can alter your own images and photographs to produce exciting and innovative designs. Black-and-white copies give bold, graphic results, whereas colour-printed imagery offers a much more subtle effect.

- Prepare an image ready to transfer print onto the appropriate acetate sheet.
- Remove any other paper you may have in your printer tray.
- Carefully place your acetate, with the correct side in the appropriate place for your printer. Printers may vary; please check before loading.
- Then simply select the print option on your computer and print onto the acetate.
- Carefully remove the sheet after printing as sometimes the ink will need a few minutes to dry.

Above right: A photograph of the patterns created by a tree reflected in water was printed onto a sheet of acetate film using an inkjet printer.

Right: This graphic image was produced by blowing up an area of the previous photograph using a computer paint program, resulting in a dramatic change of scale.

Adding colour

All acetate sheets can be coloured and, depending on the colouring mediums used, a range of different effects can be achieved, from translucent washes to solid blocks of colour.

Using acrylic paint is an easy method of getting colour onto the sheets. Some, although not all, acetates have a shiny side and a rougher or matt side. When using this type, I would suggest that painting on the rougher matt side will give better results, but this can be a personal choice, depending on the look you want for your project.

Begin by selecting your colour palette. Add a small amount of water to each of your mixing trays for each colour you will be using. Squeeze out the required amount of paint colour into each tray and mix thoroughly with the water. The addition of water helps the flow of acrylic paint on the acetate. You can add more or less to give different degrees of translucency, from completely opaque to the merest hint of a light colour wash.

Now, using an artist's brush, apply strokes of colour. Consider different ways to add your marks. You could use straight lines, curvy lines, dots, circles or other shapes. Overlap colour to get subtle blending. Try picking up a different colour on the sides of your brush; this can look more painterly and interesting. You can, of course, completely cover the whole sheet with a colour wash.

Other types of paint can also be used. When gouache is used a more opaque feel is achieved, whereas with glass paints the overall effect is more transparent, similar to stained glass.

You can also add acrylic mediums to your acrylic paint including the matt and gloss varnishes that are available. Try experimenting and see how the results vary.

Once the sheets are dry they can be manipulated in a variety of ways. They can be rolled, folded, cut into, have areas removed, be cut into strips and woven, or layered dimensionally.

Right: The sheets below layered on top of one another, showing how a design can be built up. By changing the order in which they are layered, different aspects of the individual sheets come into play, as others recede, but all are still visible.

Right: A number of overhead-projector film sheets with colour added with a mix of acrylic and gloss varnish applied with a brush.

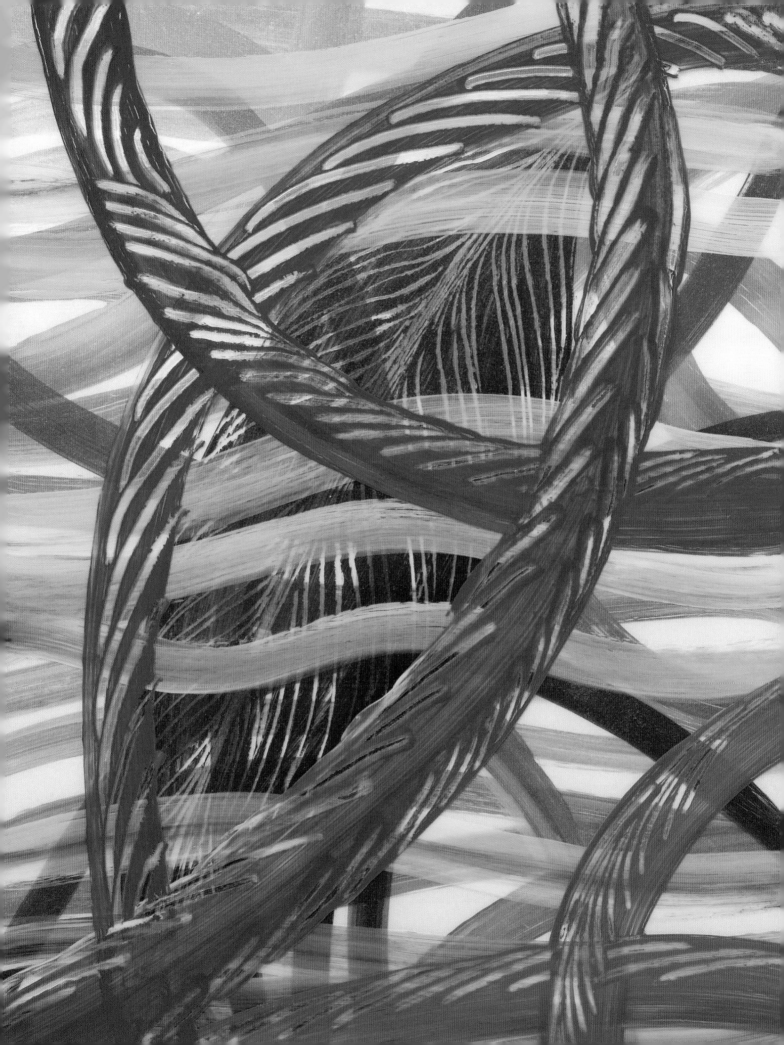

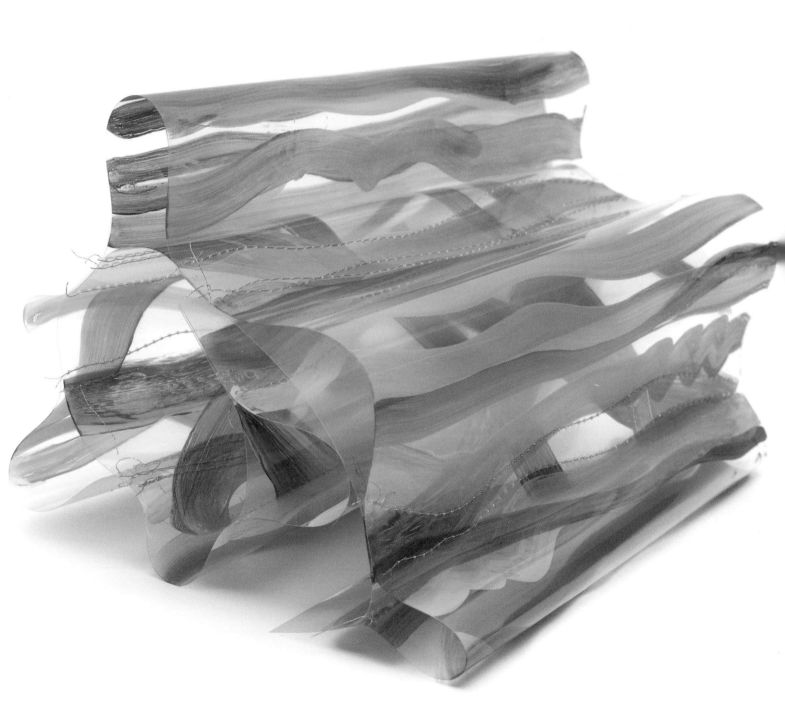

Below: Three acetate sheets stitched and manipulated together. The painted design can be seen through the transparent layers. When viewed at different angles, different patterns emerge. This image relates to the text on page 59.

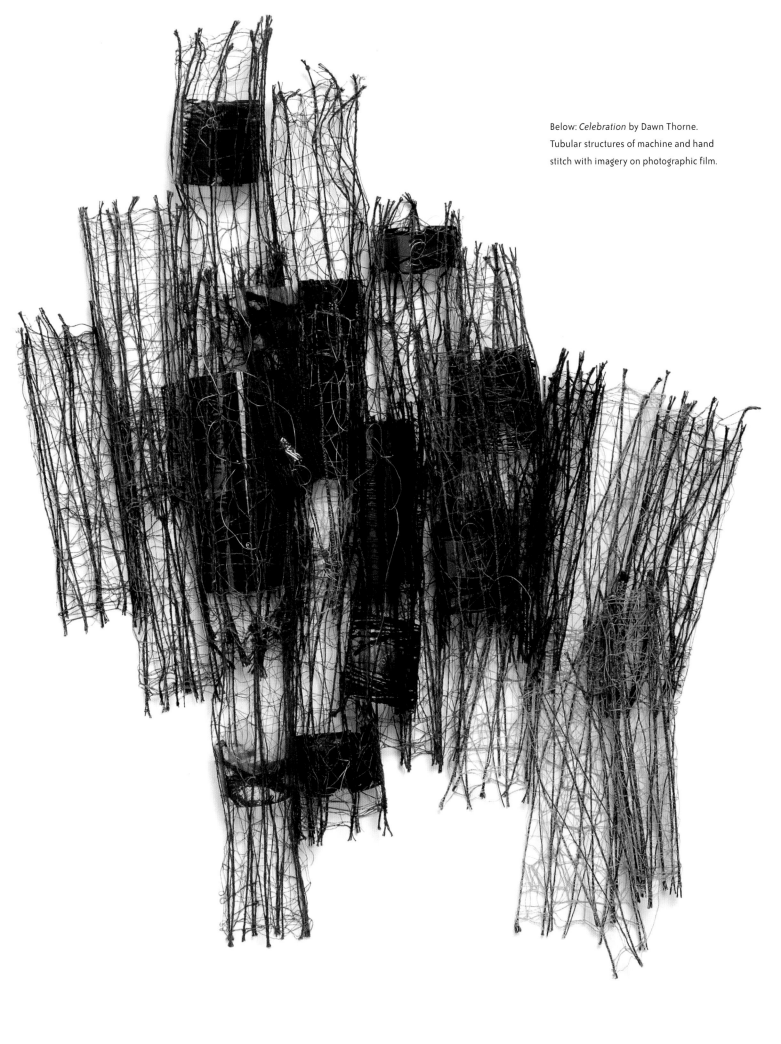

Below: *Celebration* by Dawn Thorne.
Tubular structures of machine and hand
stitch with imagery on photographic film.

Stitch and other embellishment

Stitching into acetate can be easily done, both by using hand-stitch and machine-stitch methods. Just remember that when you pierce the acetate sheet you need to leave enough of a gap that you do not rip or tear the material. This is particularly important if you use a machine zigzag stitch. If the stitching is too close the sheet will just tear along the stitch line. As a guide, a straight-stitch length of no less than 3–3.5mm is good as this will give a firm join, without tearing.

With hand stitch use a sharp needle. You will need to consider the type of thread you will be stitching with in order to select the correct needle size. As a general rule, the thicker or more textured the thread, the thicker the needle shaft, and the larger the eye needs to be. What you must remember is that it is the size of the hole created by the needle that will allow the thread to glide easily through. This is the same principle whether you are stitching into fabrics, plastics or any other type of material.

Machine stitching is similar: the size of the shaft and eye of the needle will help expedite the passage of thread. There is a whole host of different machine needles on the market for use with different threads. For example, metallic threads will stitch more easily into fabrics if you use a metallic machine needle. The same is true when using rayon embroidery threads: specific machine-embroidery needles will give better stitching results than if you just use a general utility needle. All in all, either hand or machine stitch will offer scope to aid layering and manipulative approaches when using acrylics and plastics.

Below: Photographic images transferred onto acetate film, which was then cut into squares and applied onto a waxed-paper quilt. The acetate fragments reflect light, making it dance on the surface in a fluid movement.

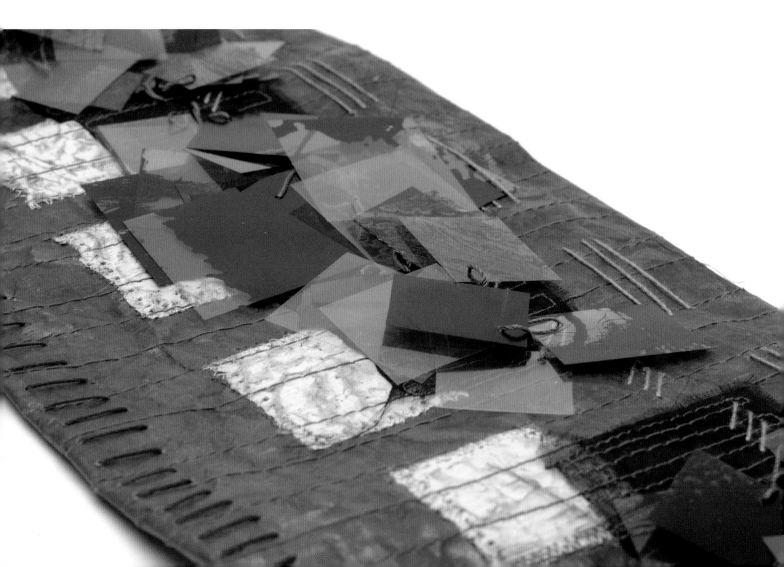

Try this:

- Take three acetate sheets.
- Colour two up in the same way, and the third in a different way – perhaps using straight lines, curved lines or grids.
- Think about how they will work together when laid on top of one another.
- Select the individual one to be the base layer.
- Take one of the remaining two and place on top of the base, then machine stitch the two sheets together at one end (the narrow width).
- Now take the top sheet and push it against the stitched line to give a dimensional pleat or roll. Again, secure this with machine stitch.
- Continue, pushing the top layer against the previous lines of stitching. Add the final sheet by butting it up to the previous one and continue stitching and manipulating in the same way to create a dimensional top layer (see the finished project on page 56).

Other methods that could be used include printing a black-and-white image onto acetate and adding a wash of colour on the back (the matt or rough side). If your images show specific shapes or individual motifs, you can cut around the shapes with scissors or a soldering iron. These can then be applied like slips to other surfaces. They too can be manipulated into position or added flat. Remember health and safety when burning plastics – wear a mask and work in a well-ventilated area.

Screen printing onto the acetate is another way of getting imagery onto the surface. Any screen-printing method can be used, as well as using Thermofax screens. The delight of using Thermofax is that your own artwork and designs can be used, allowing for very fine detail to be translated onto the screen and repeat-printed off using screen-printing inks. Unique and highly individual images can then be incorporated into your work.

Below: Acetate film fragments, mixed and combined with sheer fabrics and then applied to a woven ground, create a reflective cloth.

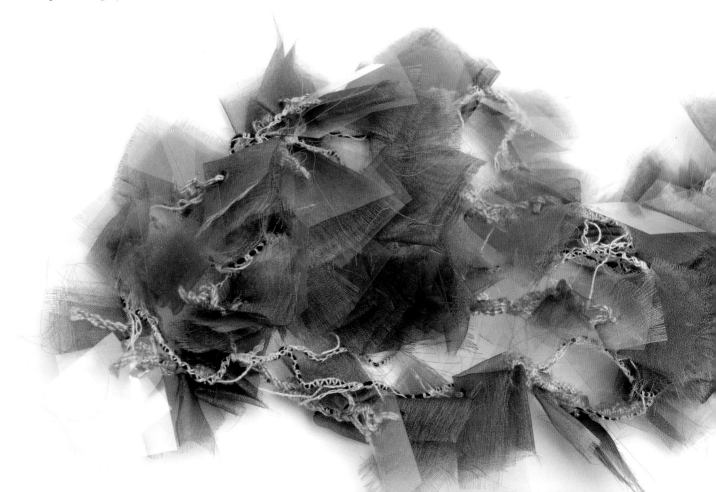

Using cellophane and lightweight film

If you apply cellophane or another lightweight film to the surface of a piece of work, it adds a reflective quality that dances with the play of light, giving extra depth and dimension. Further dimension can be achieved by layering fabrics and materials and burning these back in places to reveal glimpses of what lies beneath.

When methods of changing the surface quality of papers are combined with fusible fabric, together with mixed media, interesting and exciting results can be achieved.

It is important, whenever possible, to work to personal themes or colour schemes, as this will give rise to a considered sample. Try the following techniques:

Preparing the layers
- Select colours that are inspired by your theme or that contrast or harmonize.
- Colour-wash two pieces of calico, using a brush and painting directly onto the fabric with Procion dyes. You could also dip-dye your fabric using any favoured method. Do not over-saturate, as the fabric needs to dry. Use a hairdryer to speed up the process, if required.
- Lay out a piece of polythene (the type available from garden centres is good to use – avoid any textured polythenes, as they will cause the tissue to stick and will not be easily peeled from the surface).
- Next, mix a teaspoon of dye powder and acrylic gloss medium with a small amount of water (just a spot).
- Place a piece of tissue paper onto the polythene, and apply the dye mixture carefully onto it; try to blend colours or contrast lights and darks. Add metallic powders and/or Pearlex pigment to areas for added interest. Leave to dry on the polythene.
- Now take a sheet of Lutradur and, using acrylic paints, work colour into the fabric. Mix the acrylics with a little water to make the paints more fluid. Try to contrast the colours with the colours used on the tissue.
- Leave the Lutradur to dry. Tip: wipe down any excess paint from underneath the Lutradur with kitchen roll; it will dry more quickly.

You can either use a hairdryer to speed up any of the above samples or leave them to dry in a sunny spot. The next stage is to add embellishment and interest to the various layers, as follows:

Embellishing the tissue
Once the tissue is dry, you can print, stencil or paint design details onto it, using acrylic paint mixed with a little acrylic gloss medium. Leave the tissue to dry. Alternatively, you can dye a number of sheets of tissue in different colours, reflecting your theme. Once these are dry, tear or cut the sheets into strips or shapes, and reassemble them, piecing them together with machine stitching. This treated tissue is quite robust, but you will need to select a longish stitch length, 3.5mm or higher, so as not the tear the tissue. Pre-programmed machine-stitch patterns can add extra visual interest.

Embellishing the Lutradur layer

Using transfer paints, paint up some sheets of A4 (letterhead-sized) typing paper. You can colour-wash papers and use these for paper cutouts, or apply transfer paints to print blocks and print the typing paper. You can either print a specific design or cut out the stamped images and apply these individually.

Once the papers are dry, iron them onto the Lutradur. Use a cotton setting and move the iron steadily over the surface. Do not stay in one place as Lutradur reacts to high heat (from a heat gun, for example) and may shrink a little during the transfer process.

Creating the surface

You can now go on to layer your fabric.

- Set up your sewing machine for normal sewing.
- Make a sandwich. Lay out a piece of the calico, then the tissue, and then the Lutradur on top. Using a coloured thread to tone with your fabric sandwich, stitch closely around the edge of all four sides. Use a straight stitch, setting your machine to a no. 3 or 4 stitch length. Alternatively, you can hand baste the layers, if you wish.
- Set your machine for free machining, with feed dogs down or free machine or darning foot on. Use normal tension for both top and bobbin threads.
- Thread the machine with a colour of your choice (metallics work well, as does rayon).

Below: The finished surface, which was achieved by using layers of dyed calico, acrylic-treated tissue, coloured and transfer-printed Lutradur, cellophane and stitch.

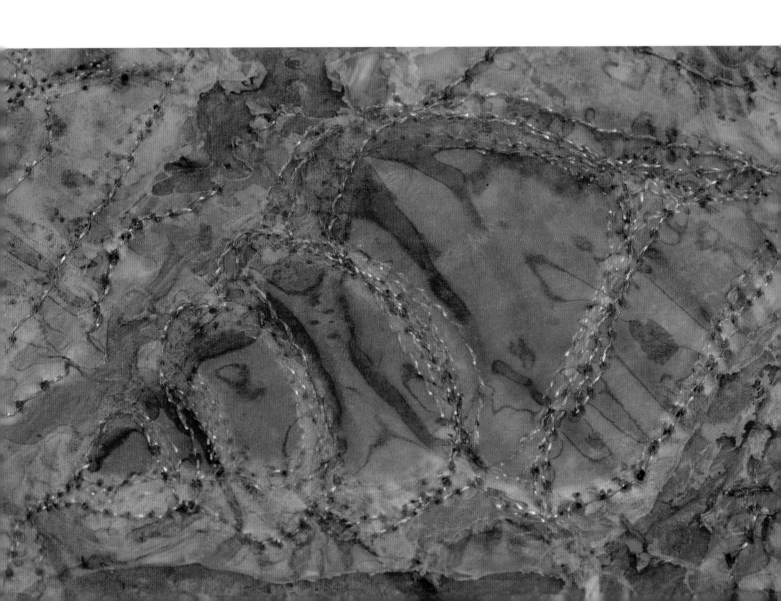

- Using your design as a guide, stitch around the shapes with straight stitch. Stitch around more than once, to reinforce the design.
- Next, thread up with another toning thread and stitch the areas between your design. You can use a meandering line or be more specific. Just remember that the stitch acts as a resist when you come to burn away areas of the Lutradur, so do not stitch too densely – aim for an open effect.
- At this point, you can look at your design and add further stitch detail and highlights to it, perhaps adding whip, granite or cable stitching in some areas, for extra texture. Introduce shadow and definition to your design, using the machine stitch to create tone and value.
- Once the machine stitching is complete, use a heat gun to carefully work at the surface areas between your stitches. Gradually erode away the Lutradur to reveal the glossy tissue surface underneath.
- You can also work at wearing away areas of the main design – it's up to you to play with the effect you want.
- You can also be more precise and use a soldering iron to remove any unwanted areas of the Lutradur surface.
- You can even use the soldering iron to create marks in the surface.

Adding another finish with wax
- To really strengthen and add another finish to the surface, you can at this point add wax to the fabric sandwich.
- Heat up a wax pot to 70°C.
- Place your fabric on some lining paper, and apply the melted wax with swift brushstrokes all over the surface of your made fabric, making sure all areas are covered.
- Place the waxed fabric between two sheets of absorbent lining paper and, using a hot iron (cotton setting), iron off the excess wax. This also allows the wax to penetrate through the layers of the fabric.
- You may wish to do this a few times with fresh paper. The colours will darken slightly, but get brighter as more of the excess wax is removed. They will not, however, be exactly the same as the colour prior to waxing.

Finishing touches
- Now you can add highlights with transparency. Cut out shapes in cellophane and stitch them onto the surface, add further detail with the treated tissue and apply areas of acetate to the surface. Use the acetate to create dimensional additions, combining it with other materials. Alternatively, you can completely cover the fabric with acetate or cellophane and use the machine to reinforce the shapes with stitch. Take the soldering iron and work around the shapes to remove unwanted areas of transparency. Highlight with further machine or hand stitching.
- You could also use acetate film. Take the film and, using scissors or a craft knife, cut shapes that are inspired by your design. Consider changing the scale or selecting an element or section of the main design. You can also use a soldering iron to cut out your shape, although this can be a bit smelly, so wear a mask and work in a well-ventilated area if you choose this method.

- Apply the acetate to the surface of your fabric. Apply directly over the design or offset it. Overlap and layer it. Play around with your placement before stitching around the outside edge of the shapes to secure them, using free machining. Again, select an appropriate thread colour.
- In addition to the acetate film, add torn or cut shapes from the acrylic-treated tissue; this adds another reflective dimension. Attach these shapes in the same way. Also layer and overlap them with the acetate, for a different effect.
- Finally, if you wish, add texture and interest with hand embroidery: use stitches to highlight and firm up some areas, and to unify and link others.

As with many processes in textile art, anything goes. Once you have tried this method of creating a reflective surface, you can play around with numerous different combinations. For example, you can apply acetate film to the whole of the surface and either leave it as it is or remove areas with a soldering iron. You can also laminate papers and fabric, using a laminating machine (see page 73), and then cut shapes from the laminated sheet and couch these in place by hand. (It's a bit tough to stitch through, but it can be done.) You can also use photographs, printed onto thick acetate.

Perhaps you might try printing or painting onto the acetate surface with glass paints or alcohol inks. Once your piece is finished, you can apply acrylic gloss medium to the whole of the surface for another effect.

Your finished surface can be made into bags, book covers (see page 64), a wall panel or cut up and applied to other surfaces.

Below: Variation showing cellophane applied in squares onto a waxed and treated surface.

A simple book cover

To make a slipcover for an A5 (5⅞ x 8¼in) sketchbook, follow the instructions below. The measurements can be adjusted to fit any size of book.

- Make up your fabric as instructed in pages 60–63, large enough to be used for your book with a little extra allowance. Then cut out a rectangle measuring 22 x 45cm (9 x 18in) from the fabric.
- Cut out another piece of calico the same size as the first one. This piece will be used as the lining and can be dyed, printed or left plain.
- Place the made fabric on top of the calico and baste in place around the edge. Using a close zigzag, machine stitch down the two short edges. You may need to pass the machine over a couple of times to get a closely worked satin stitch.
- Fold in the two stitched edges by approximately 4cm (1¾in), to make pockets. With the made fabric facing you, work a close zigzag along the two folded sections and along the longer edge. Take care when working the folded areas. Now slip the finished cover over your sketchbook. Add decorative cords as closures or ties, if you wish.

Below: Examples of handbound books with slipcovers showing a variety of surfaces created using dyed calico, waxed, dyed and varnished tissue, Lutradur and cellophane, all enhanced with machine stitch and some hand stitch.

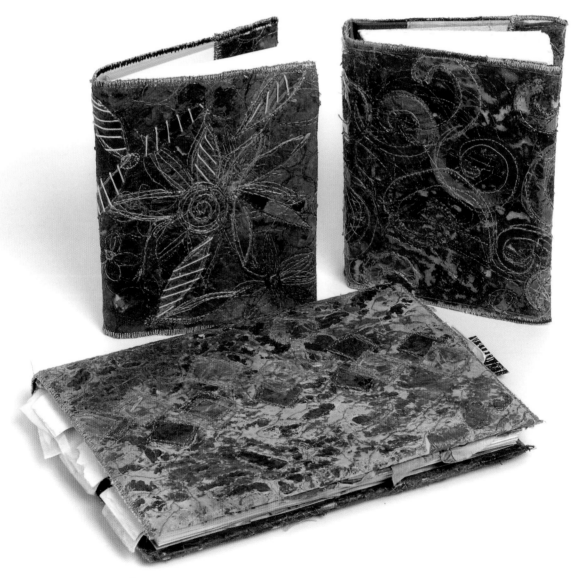

Acrylics and plastics

Rigid acrylic sheeting can offer an exciting addition to your stock of materials for working with transparency. It's particularly useful for creating dimensional work. Acrylic sheeting comes in various thickness, and sheets up to 6mm (¼in) thick can be cut with relative ease using a Stanley or craft knife.

Other methods of cutting include sawing with a jigsaw or laser cutting. The latter is not included in this book because it is expensive and specialist equipment is required.

Cutting with a craft knife

You will need:
- Cutting mat
- Craft knife or Stanley knife
- Metal ruler
- Acrylic sheet
- Pliers
- Pencil or ballpoint pen

The acrylic sheet comes with a protective plastic layer on both sides. This prevents any unnecessary scratching to the surface. It can, however, prevent you from getting a clean cut.

Method:
- Using a craft or Stanley knife, measure and mark on the protected surface of the acrylic sheet where you want the cut to be, using a pencil or ballpoint pen.
- Next, score along this line with your metal ruler and knife. Press firmly, but not too hard. It will take a number of passes to enable you to crack the sheet in half.
- Before going any further, carefully peel back the top protective layer. You can leave the bottom layer intact at this point.
- If you pressed firmly enough, you will be able to see the score line you have made. Reposition your rule over this line and continue to draw the knife along the line; you will need to make up to 20 passes or more, depending on the thickness of the sheet. Note: you will not cut right through or even halfway, but it will be enough for the process.
- Now peel away the bottom protective layer and position the sheet with the scored line along the edge of the edge of a table or workbench, just allowing the score line to project about 1cm (½in).
- Either clamp the area of sheet to the top of the table or hold it down firmly with one hand and use the other hand, with some force, to push down on the exposed edge of the sheet. The sheet will crack and break, giving you a clean cut.
- Should any shards still remain on the cut edge of the sheet, these can be nibbled away using pliers.
- The next stage is to smooth the cut edges (wet-and-dry sandpaper will do this very successfully). Wear a mask, as the fine dust can be an irritant. Once the smoothing is complete, your sheet is ready to use.

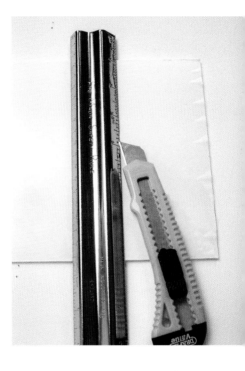

Above: Basic equipment for cutting acrylic sheet: a metal ruler and craft knife.

Drilling holes

Drilling holes into the acrylic sheet is a straightforward process and easily achieved using an electric or hand drill. You just need to protect the area to be drilled before you start, to avoid any slipping or cracking.

- Decide where any holes are to be placed and put masking tape in that position.
- With a pen or pencil, mark the exact spot to be drilled.
- Use an awl or punch to make a small starter hole. This will give the drill bit a place to grip onto and prevent any movement when you start drilling.
- Place a piece of wood on your work surface and then place the acrylic sheet on top. The wood will protect the work surface as you drill through the sheet.
- Position the drill into the punched mark and, pushing down firmly, switch on and bore the hole.
- Take care at this point not to jiggle the drill about, as this may cause the area around the hole to crack and splinter.
- You will get a build-up of material around the hole as it reacts to the heat of the drill, but this can be just brushed away afterwards.

Holes are great when you want to connect and join sheets together, or for applying the sheet onto another surface, fabric or piece of work. They can act as your stitching holes and may be as fine as a needle or large enough to take a rod: it just depends on the size of your drill bit.

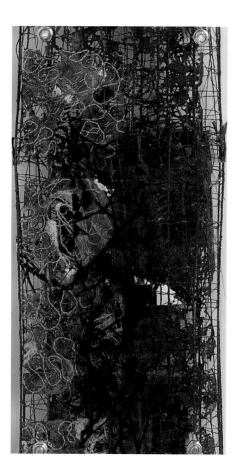

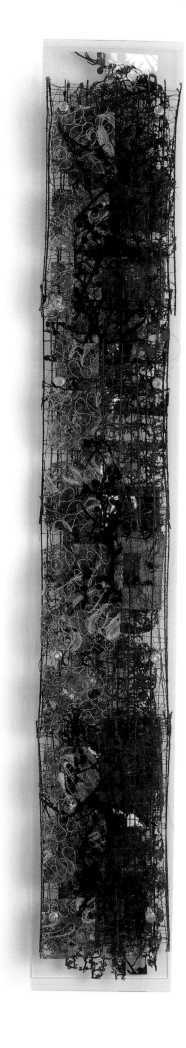

Left (detail) and right: *Oiseaux* by Dawn Thorne. Transparent layers of acetate film and photography on a hand- and machine-woven structure, with machine stitch on horticultural fleece, transferred images, metal and resin.

Right: Screen-printed polypropylene sheet, cut using a craft knife, with holes drilled and laced together with embroidery thread. As the structure is jointed, it can be manipulated in different ways.

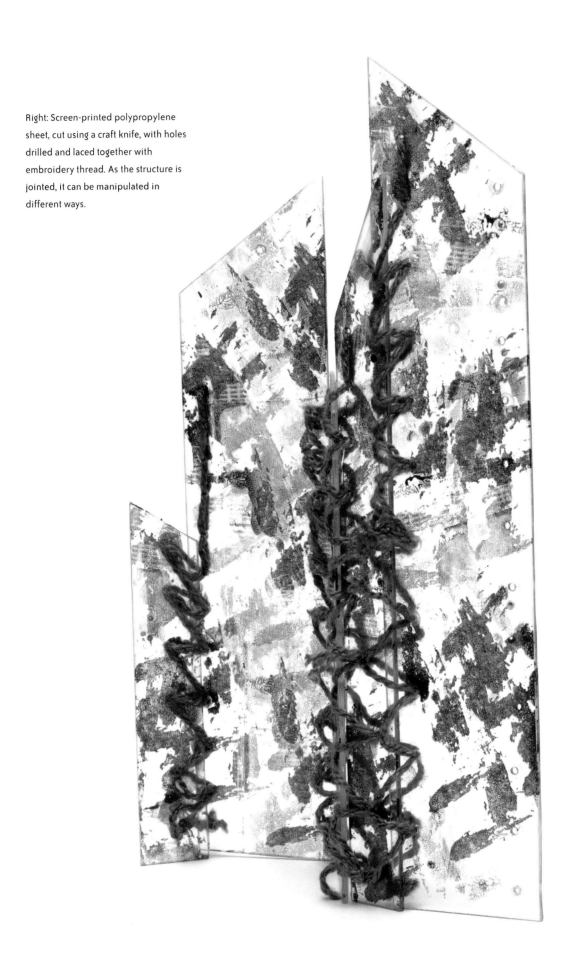

Drawing into the surface

Because acrylic sheet is soft, marks can be made into the surface, using a printmaker's scribe or other sharp instrument. Any type of mark can be made in a similar way to that made with traditional graphite or fineliner pens.

The marks alter the surface, giving it a more opaque finish. Try crosshatching, creating dots, lines, squiggles and so on, as if sketching with a pencil. You will find that fine detail can be produced successfully.

These scratched marks show up as white on the surface, but you can rub printing colour onto the sheet to highlight them, if you wish. Just apply the printing medium or acrylic paint all over the sheet and then, with a soft cloth, remove excess colour. The colour will settle in where the scored marks are, defining them.

You may also wish to have some areas of your sheet that are opaque, perhaps as a specific part of the design or just because you wish to make a section more opaque. If you rub the surface with a household scourer or sandpaper, interesting levels of translucency are created.

When working a design on the sheet, consider how you can combine a variety of marks and methods to achieve the desired effect in the same way in which you would approach designing on paper.

Below: Acrylic sheet, worked into with a drypoint tool, wet-and-dry sandpaper and a kitchen scouring pad.

Left: Marks can be made into hard acrylic and plastic surfaces using mark-making techniques, crosshatching, swirls and squiggles. See also Worksheet 1 on page 120.

Burning

Incredibly exciting results can be gained by burning the acrylic sheet. A cook's blowtorch is probably to be found in most kitchens and this works well, as it has a fine-tip flame, which offers you more control than a normal blow torch.

Safety notes

Make sure you work in a well-ventilated room, near an open window; a garage or outside is probably best, as the process will give off fumes. Wear a protective face mask and goggles.

Place the acrylic on a suitable surface — a paving slab or metal table are good. Choose nothing that will burn or potentially catch fire during the process.

- Mark the areas you wish to burn with a chinagraph pencil.
- Next, take your torch and slowly work the area you wish to burn in a continuous movement, avoiding aiming at one spot. Making smooth, rhythmic movements will prevent the surface from reacting in an uneven way.
- The surface will start to become white and opaque. It will then produce tiny bubbles and you will see the surface starting to melt.
- Finally, it will begin to burn around the area you have been working. Allow the flame to do its job and continue to burn away at the edge of the shape.
- When you are satisfied with the area which has been burned away, snuff out the flame. The acrylic will still be very pliable at this stage. It will also be extremely hot, so take care to avoid any skin contact with the surface.

Above: Holes can be created by applying heat and working within an area. Here, a cook's blowtorch is used as the heat source. Always remember to wear a mask and work in a well-ventilated area.

Larger holes

Another method, if you wish to have larger holes, is to remove that section of the acrylic sheet entirely.

- Take a 15cm (6in) square sheet of 4mm (⅛in) acrylic.
- Using a compass, score a hole 6mm (¼in) in diameter in the centre.
- With a fine drill bit, drill four holes at regular intervals, just inside the scored line.
- Take a tenon saw fitted with a fine saw blade and loosen the end nearest to the handle so that the blade is only secured at one end. Now thread the free end of the blade through the hole you have just made.
- Place the blade back in its slot and tighten the screw.
- Place the acrylic sheet flat on a work surface, with the section that has the saw attached protruding over the edge a little way.
- Holding the saw vertically and at right angles to the piece of acrylic, make two or three passes of the blade in a downward motion to create a notch.
- Begin sawing in up and down movements, following the scored line.
- When you come to complete the circle, make sure that the saw line connects to the starting point. The circle will then easily pop out and you will be left with a large hole.
- The edge of the hole could just be sanded smooth and left, should you wish. However, to achieve a more eroded and organic appearance, burn it away at the edge so that it melts and distorts. The molten plastic rises up on the surface, producing wonderful textures.
- Alternating the side of the heat source will also alter the final results.

Working a series of holes over the surface will enable you to stitch through the acrylic.

Burning away at the surface of acrylic sheet is not an exact technique, particularly when worked in a low-tech home environment. Spontaneous things can happen, which produce unexpected, exciting results. The only way to gain experience by working and exploring burning methods is to play around with samples, photographing, recording and noting the results in a workbook.

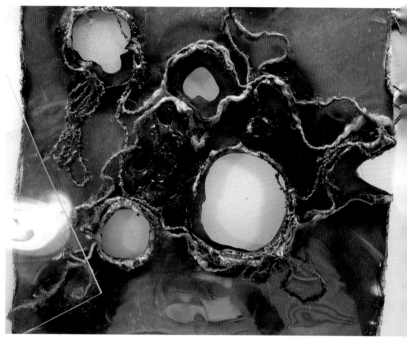

Below: Larger holes created by burning into acrylic; see how the material bubbles up onto the surface. Extra embroidery thread adds detail.

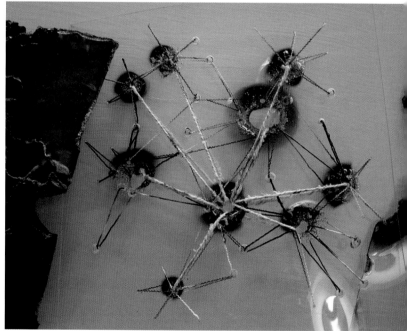

Right: In this example, stitching has been incorporated, with the holes allowing the thread to pass through. Both examples on this page are by Alexandra Duncan.

Bending with heat

Acrylic is sold as flat sheets, but commercially it can be moulded, bent and manipulated into almost any shape you can think of. Although most applications are beyond the realm of our usual DIY resources, plastics and acrylics can be bent quite successfully using a domestic oven and/or a cook's torch.

When heated, sheets become soft and can be shaped by your hands, pushed into moulds or pleated. Your results will only be limited by the thickness of the sheet you use. Generally, acrylic sheets of up to 4mm (³⁄₁₆in) thickness will give very satisfactory results and with relative ease. Anything beyond 6mm (¼in) in thickness will take much longer and will require more sustained heat.

When using a domestic oven, it is advisable to limit the thickness of sheet you use in it to 4mm (³⁄₁₆in).

Take a 25cm (10in) square of 3mm (⅛in) acrylic sheet and place it on some thick aluminium foil on a baking tray. Use a tray specifically for this purpose and do not use it for food again.

- Place the tray in an oven, pre-heated to 150 degrees Celsius. The plastic will begin to soften after about five minutes, depending upon the thickness of sheet you use (a 1mm sheet will take less time to soften than a 4mm sheet).
- Take care not to overheat the plastic, as this will produce toxic fumes with an unpleasant smell. Check how it is progressing at one-minute intervals.
- Once the sheet has softened, remove it from the oven and, wearing a pair of cotton gloves, pick it up and bend, mould and manipulate it into a shape. The sheet will harden quickly, so be prepared to work fast.
- If you have not achieved a desired result, you can pop it into the oven again. When reheated, it will return to its original shape. There is a limit to how many times you can reheat and rework plastics, however, as overworking will cause the material to become brittle and break.

Above: Acrylic sheet bent into a right and an acute angle using heat. A gas torch was worked up and down the sheet in a straight line where the bends were needed.

MAKING CURVES

To bend acrylic sheet into curved shapes you can use a mould. Try the following exercise:

- Cut sheet into strips, say 2.5 x 25cm (1 x 10in) long. Heat these to soften them and then form them around a glass jar or cardboard tube, or spiral them around a wooden dowel.
- Repeat the process to form the other pieces into the same shape.
- Link and join pieces, with stitches or wrapped cords, or intertwine coiled elements to produce an all-over jointed 'cloth'.
- Vary the sizes to give a change of scale. Patterns can be built up in this manner.

Bending with a blowtorch

When plastics are heated in the oven, the whole of the surface becomes soft. When heating with a heat torch, specific areas can be targeted, enabling you to produce pleats and bends at precise and controlled points across your sheet.

- Take a 10 x 30cm (4 x 12in) strip of acrylic. Mark it with a chinagraph pencil along the length, marking at regular intervals approximately 5cm (2in) apart or wherever you may wish to form a bend in the sheet.
- Turn on your torch and, holding it about 10cm (4in) from the surface of the sheet, make sweeping movements across the drawn marks. Be careful not to discolour the sheet. You will see a change in the surface as the sheet becomes soft. The moment you observe this change, turn off the torch and pick up the strip. Where you have applied the heat, bend along this point, using gloved hands. The sheet will readily bend to any angle you wish. You will even be able to completely fold it in half. Again, you need to be speedy, as the sheet will cool down very quickly. Once cooled, the sheet will become completely rigid once more and your fold will stay in place.
- Repeat, heating along your drawn lines and bending until you have completed all the bends and folds.

Below: Two examples of laminated acrylic sheet. In the piece on the left, a free machine-embroidered addition has been sandwiched between two squares of acrylic, leaving the edges exposed. The piece on the right has fragments of copper shim and silk paper trapped between the layers.

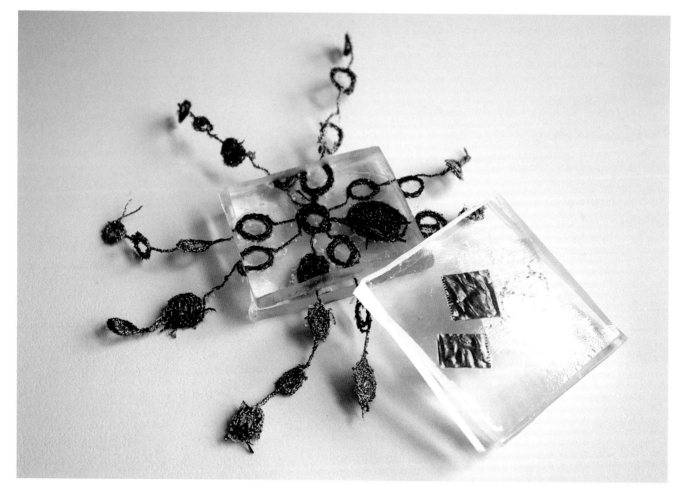

Laminating with acrylic

Small fragments of stitch and textile, flowers, wire and metal shim can be sandwiched between sheets of acrylic. A hot press, such as a heat-transfer press, is the ideal tool for this technique, but if you haven't got one and don't have access to one, you can use a domestic oven, a metal sheet and some clamps.

You will need:
- Heat-transfer press or a domestic oven, heated to 150 degrees Celsius
- Two sheets of stainless steel (available from DIY stores)
- Two G-clamps

Method:
- Cut out two small rectangles from a piece of 3mm (⅛in) acrylic sheet, each roughly 7.5 x 10cm (3 x 4in) or slightly smaller (the exact size is irrelevant).
- Place the textile or other item to be laminated between the two pieces, to create a sandwich.
- Put the sandwich into the pre-heated oven and heat until soft.
- Remove the sandwich and place it between the two sheets of stainless steel.
- Clamp all the layers firmly and leave until completely cooled.
- Once cooled, remove the clamps and metal sheets to reveal the hardened plastic sandwich. The item in the middle will be permanently trapped between the transparent sheets.
- The edges can be sanded and holes can be drilled to enable the laminated patches to be attached to other surfaces or linked and joined with stitch. Use wire as an alternative to thread, for a different look.

Using a laminator

As well as using plastic sheet to laminate items, you can laminate cloth and thin metal or other thin materials, such as flower petals or leaves, using a domestic laminating machine.

Laminating machines use special laminating pouches, which can be readily bought from most stationery shops and some supermarkets. They come in various sizes, to suit the size of your machine. You can use smaller sizes than the size of your machine, but larger sizes will obviously not work.

A number of items can be trapped and laminated on one sheet; you just need to allow enough space around each item to ensure that the sides of the laminating material can fuse together, surrounding each item.

You will need:
- An A4 (letterhead-sized) laminating machine
- A4 (letterhead-sized) laminating pouches
- Fine textiles, metal, foliage or other items to laminate
- Scissors
- Cutting mat and craft knife

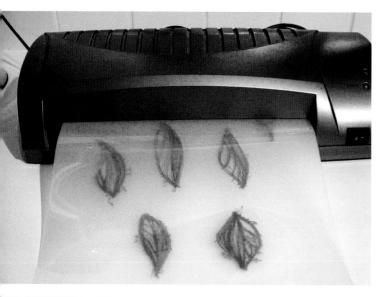

Method:

- Take one laminating pouch and peel apart the two layers. The pouches are joined along one short end.
- Position your items over the inside surface of the bottom layer of the pouch, remembering to leave enough space between each object.
- Once you have placed your items, bring down the top sheet over the bottom, so that the items are now trapped between the two sides of the pouch.
- Turn on the laminating machine and wait for it to heat up, when the 'ready' light will come on.
- Place the pouch in the slot provided, with the joined end first.
- The machine will start to feed the sheet through – do not push it. As the pouch goes through the machine, the heat fuses the pocket together, sealing in the items you have placed inside.
- Wait until the machine pushes the sheet all the way through, and then remove it.
- Where you have left gaps between items, the two sides of the pouch will have fused together. You can then cut around these shapes and use them to apply to cloth, create jewellery, form a fabric or create a structure.

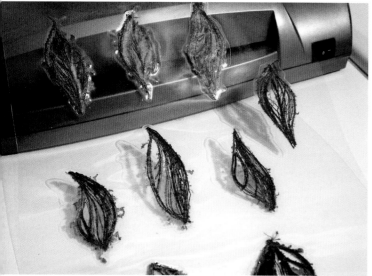

Top left: Machine-stitched leaves that have been placed inside the lamination pocket being fed through a laminating machine. Note the spacing between the leaf shapes.

Middle left: The finished sheet emerging from the lamination machine. The leaf shapes are completely enclosed.

Bottom left: The shapes can be cut out using either scissors or a soldering iron.

Gels

Acrylic gel mediums are available in a range of finishes, such as matt, gloss, semi-transparent and pearlescent. Some gels have bits added to them to give a textured finish. Sand, mica flakes, and fibres are a few of the types of particle that are combined with gel media. Almost all gels dry clear, except the tinted ones, but even these will have a transparent quality.

You can also create your own textured gels, giving you greater control over the type of surface finish you create.

You can add a huge range of small items:
- Fabric and thread snippets
- Sand
- Tiny beads
- Plant material
- Glitter
- Seeds

In fact, almost anything can be added, within reason. Coating the surface of fabrics and papers with acrylic gel media will alter the surface quality. Some will provide a glassy gloss appearance, while others add texture to the surface.

As a rule, any gel added to a surface will allow that surface to remain pliable and, as an added benefit, will provide a protective layer.

Below: Heavy gloss medium applied onto an inlay design gives a glassy layer across the surface.

Polymer resins

Several resins that are suitable for casting are available, including acrylics, urethanes, polyesters and epoxies. These are the ones that are most widely used by artists. However, acrylic resin needs to be worked at high temperature and under high pressure. Specialist equipment and moulds are required and the product remains toxic while in its uncured state. Because of this and because most textile artists are restricted to working in a spare bedroom, garage or small studio, acrylic resins are not covered here. They are best left to the professionals. In this section of the book we will concentrate on the pourable resins that set at room temperature, especially casting resin.

Polyester resin is the most common resin that is used for casting. There are a number of casting resins on the market and you should refer to the manufacturer's instructions, which can vary slightly. It is important to follow the instructions carefully, as improper use can be dangerous. They must all, however, go through a similar process in order to become hard.

Casting resin is one of the thermosetting plastics. These consist of a two-part system: the resin, which comes in a pourable liquid form, and a catalyst. Once the catalyst has been added, the liquid resin becomes solid. After this, it is impossible to reverse the process.

You can control the rate at which the resin hardens by adjusting the amount of catalyst you use. If you use too much catalyst, however, this will cause the hardened block to crack or become cloudy. The resin I use requires approximately 100ml of resin to 1ml of catalyst.

The temperature of the room will also have an effect on the curing time. If you are working outside or in your garage, you will find it can take up to 48 hours to set. Alternatively, in a warm-to-hot room it may only take a couple of hours for the resin to become hard. This is something you will need to take into consideration when you work with this type of product.

Mixing resins

You will need:
- Casting resin
- Catalyst plastic
- Disposable cup for mixing
- Plastic or wooden stirrer
- Mould suitable for casting

Method:
- Carefully pour the desired amount of resin into the disposable plastic cup.
- Measure out the catalyst – refer to the manufacturer's instructions.
- Again, carefully, add the catalyst to the resin and thoroughly mix the two together. Great care must be taken during the mixing process as it is at this stage that you are most likely to produce air bubbles, so mix slowly and gently. You will also need to mix thoroughly; if you fail to do this, the resin will not set properly.
- Once all air bubbles have gone and you are sure that all the catalyst and resin are combined, pour the mixture into the mould.
- Yet again, be careful, as you do not want to create any of those air bubbles you have worked so hard not to get.

Right: A stitched sample using a combination of waxed metal shim and monoprinted papers. A layer of clear resin has been applied across some of the surface, giving it a glassy quality.

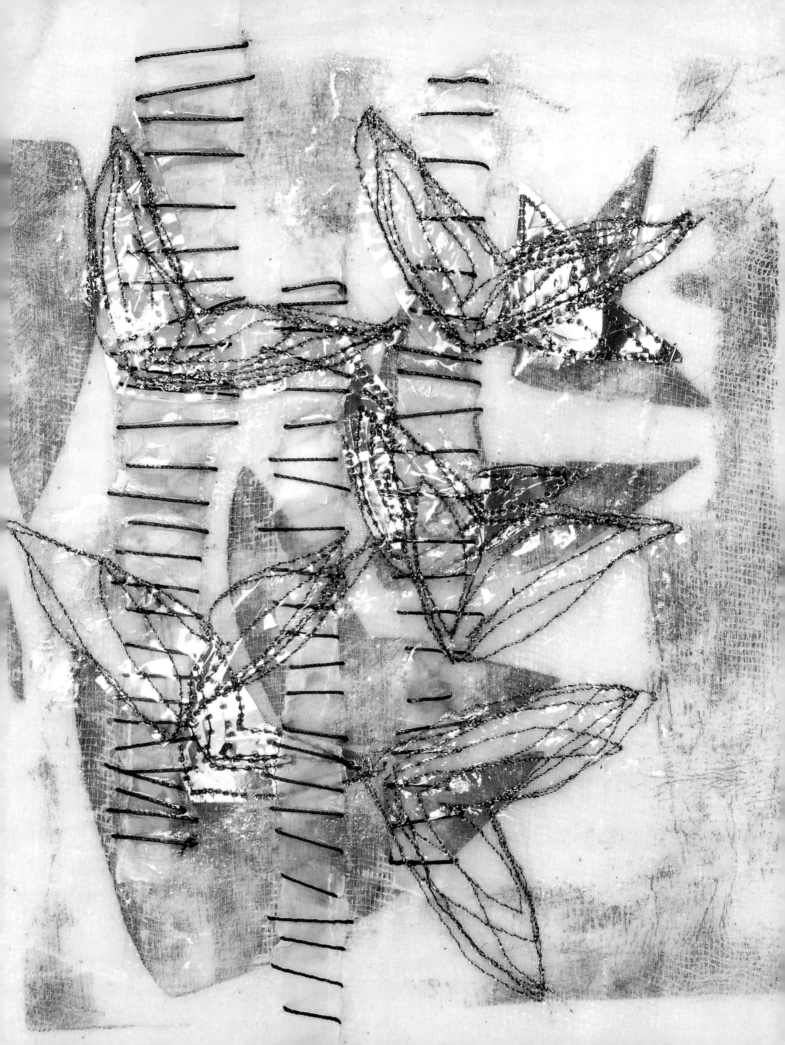

Coating with resin

Before we look at casting items in resin, let's briefly look at other methods of using the mixed resin.

Fabric and paper, when dipped or painted with resin, will take on a glassy appearance, with the resin giving the look of a clear overlay as well as protecting the surface. The amount of resin you use to coat your paper or fabric governs how firm the final result will be. If you simply give a sheer all-over wash, quite a reasonable level of pliability will remain, so you can still play around with a degree of manipulation. Applying many coats to the surface will enable you to build up layers gradually to the point where the treated fabric or paper becomes stiff and solid.

- Mix the resin according to the manufacturer's instructions. (There is no need to pour it into a mould.)
- Place the item to be treated on a piece of polythene.
- Dip a brush into the mixed resin and then paint the resin onto the surface of the item.
- It's up to you how thinly or thickly you coat the surface, but remember that the thinner the coat, the quicker it will dry.
- Once the surface is dry, turn the item over and apply resin to the other side. You can build up thin layers until you are happy with the outcome.
- Alternatively, you can pour the mixed resin into a deep container; dip the item into it, and then carefully lift out the coated item and peg it out to dry. Remember to place a drip tray underneath, as the resin will continue to drip until it begins to set.
- Repeat the dipping process until the desired effect has been achieved.
- Always wait until one layer has set before adding the next.

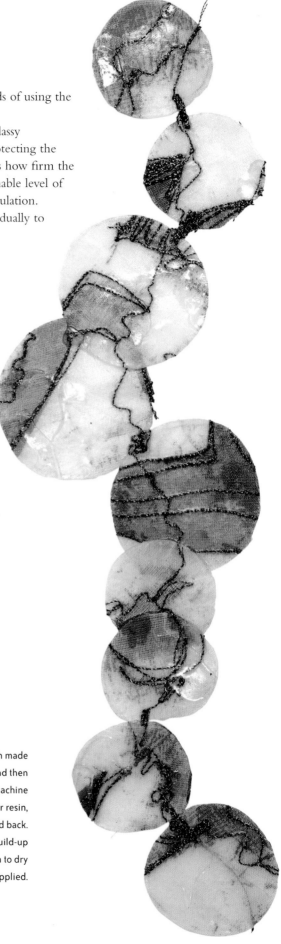

Right: Circles cut from a cloth made from organdie and paper and then waxed have been linked with machine stitch and dipped into clear resin, coating both the front and back. Several dippings will allow a build-up of resin. Allow each coat of resin to dry before the next is applied.

Casting with resin

Casting resins allow objects to be cast using silicone or rubber moulds, and you can also embed objects to create jewellery items, additions, paperweights and bricks. Smaller cast pieces can be joined to create an interesting cloth or larger bricks can be part of a series used to create installations.

MOULDS

These can be made out of various substances:

- Plaster of Paris
- Silicone rubber
- Latex
- Wood
- Wax
- Clay
- Plastic

EMBEDDING WORK

Textiles, ranging from fine, delicate scraps of machine lace right through to heavily textured and embroidered patches, can be encased in resin, as well as papers or acetates – in fact, any object can be buried in resin. Because textiles are porous, you will need to coat the textile prior to casting, either in the same type of resin you are using for casting or in varnish.

If this is not done, then there is a tendency for the object to lift between the layers and not lie flat. Some distortion may be what you want, but it is something to bear in mind if you require a perfectly flat trapped textile.

Below: Two examples of embroideries that have been cast into resin blocks. The one on the right has evidence of bubbles, which shows that the resin was not mixed carefully enough before pouring. However, this may be an element you want to incorporate into your design.

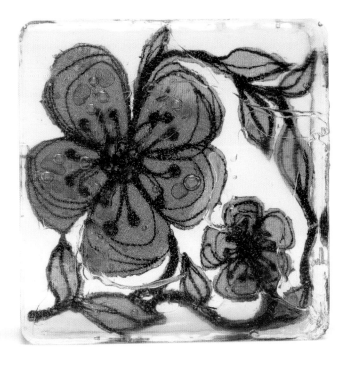

You will need:

- Resin and catalyst
- Plastic cup and stirrer for mixing
- Mould
- Object or textile to be embedded

Method:

- Mix up some resin and catalyst. Remember to mix slowly and thoroughly, but this time only make up half the quantity you will need to fill the mould. (Embedding items is a two-part process and we will mix the rest once the first layer has set.)
- Carefully pour the mixed resin into the mould. Set this aside, covering it lightly with some foil, paper or clingfilm (Saran Wrap).
- The drying-out process can vary, depending on the temperature of the room and different manufacturers' curing times. As a rule, the shallower the layer, the quicker it will dry. During the drying process, the resin will transform into a gel-like substance that will become tacky to touch; this is normal and part of the process.
- It is advisable to coat any porous surface with some mixed resin or varnish and allow this to dry before placing the item on the tacky resin surface.
- When the surface is almost set, but still quite tacky to the touch, it is time to add the textile and the next layer. Select the treated (if applicable) item and carefully place it on the surface of the almost-set resin in the mould.
- Press down firmly once you have placed it exactly where you want it, making sure all areas are in contact with the first resin layer.
- Next, mix up some resin and catalyst, as before, and carefully pour it over the top of the trapped item and the first layer.
- Cover as before and leave to set. Covering will help to prevent a tacky surface after the resin has completely set. The tacky feel is due to a reaction with air. It can, however, be easily removed with acetone or wet-and-dry sandpaper. (Not all resins will have a tacky feel, even when set uncovered.)
- When the resin is completely dry, it can be easily removed from the mould.

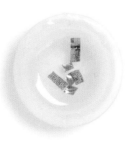

Above: All sorts of moulds can be used to hold the poured resin. The example on the top right shows the gel-like stage with its rippled surface. Fragments of embroidered cloth and copper shim have been encased within the resin.

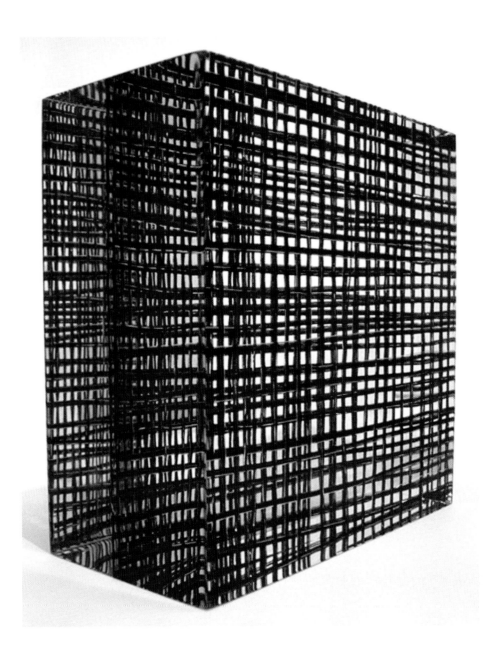

Left: *Grid Weave* by Laura Thomas.
Cotton, silk and Lurex encapsulated in
acrylic. 16 x 16 x 8cm (6¼ x 6¼ x 3⅛in).

Tip
All resins will shrink when set. This is due to part of the polymerization process. As resins set from the inside out, the last part to harden is the surface that is in contact with the mould, so be sure this is completely set before you remove the resin shape.

- Once removed, the resin block can be polished, filed, sawn or even turned, like wood, on a lathe.

Health and safety
Always remember to wear a mask to protect you from fine particles when sanding, sawing or even polishing plastics and resins. Goggles may also be advisable.

Finishing touches

There are a number of finishing techniques you can use on your resin block.

POLISHING

If you wish, you can just leave the block as it is and not polish at all. If you want a polished surface, you can use different grades of jeweller's rouge for this process, right up to a high-shine rouge called Hyfin.

- Take some jeweller's rouge and rub it over a polishing cloth. Begin to buff up the surface of the resin block, using the cloth. Polishing is quite a labour-intensive exercise, so take your time. You will need to be fairly firm with your movements.
- When the block begins to take on a more polished look, change to Hyfin and continue to work all over the surface until it is highly polished.

A resin block can also be polished with a liquid metal polisher, such as Brasso. Just apply the liquid to a polishing cloth and work it all over the surface of the block.

FILING AND SAWING

Using a metal file, edges can be smoothed and a degree of bevel added, if wished. Simply move the file in smooth, even strokes along the edges, angling it to achieve a bevel. You can saw blocks in half with a jigsaw or tenon saw.

COLOURING

Resins can also be coloured. As usual, each manufacturer will provide the necessary colourants for their resins.

Opposite: *Du Souffle de la Terre, Petit Format de Voyage* by Hélène Soubeyran, France. Textile encased in resin.

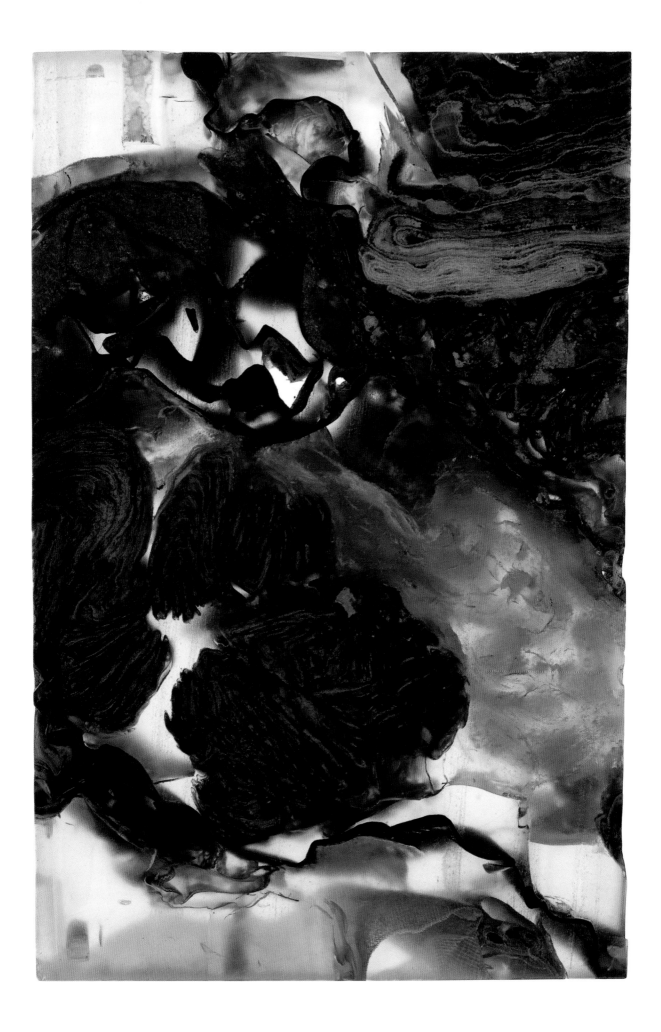

4 Defining Structure

Whenever you work with transparency, the main source you require in order for the transparent aspect of your design to show is light. Whether the light is natural or artificial, it is an important part of the design process, if your work is to realize its full potential and say what you want it to say.

Natural light

Natural light is the most readily available source to illuminate your work. Natural daylight also affords the advantage of providing an interactive aspect, as it will alter over the course of a day, changing the appearance of the work as the changing light passes through the layers. At the same time, light is also affected by the changing of the seasons and the position of the sun in the sky. All these factors will alter the appearance of a transparent or translucent piece of dimensional work.

Opposite page, top: Tea-dyed woven strips of cotton muslin, with hand-stitch detail in silk thread. The fabric weave is defined as light travels through the piece.

Opposite page, bottom: Procion-dyed cotton muslin with machine stitch, randomly pleated across the surface. When exposed to light, the pleated areas give a strong contrast to the rest of the fabric.

Below: Squares of organdie fabric are linked, joined and assembled to form a concertina-like structure. Light casts shadows as it filters through the piece's layers and folds.

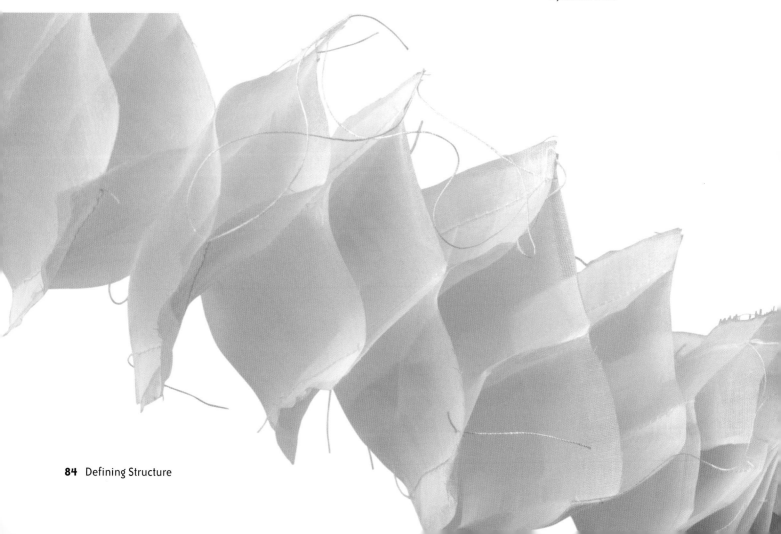

One of the most exciting aspects of dimensional transparent design work is this influence that light has upon it. You almost need to consider light as another design tool, in addition to the usual design basics.

By factoring in how the play of light will respond, additional dimensional effects can be considered. Shadows will be cast from the shapes and forms you use. The position of the work in relation to the light will show a variety of effects. The intensity of the sunlight will change the intensity of the cast shadow, from barely visible, soft, subtle and dappled shadows to dynamic, strong, dramatic or black, giving the illusion of solid form.

Shadow and light can make the work come alive and in some instances the shadow could well be the work itself. If you feel that your structure is best displayed under constant rather than changing lighting conditions, you should consider using artificial lighting, such as fibre optics (see overleaf) or other forms of electric light (pages 88–91).

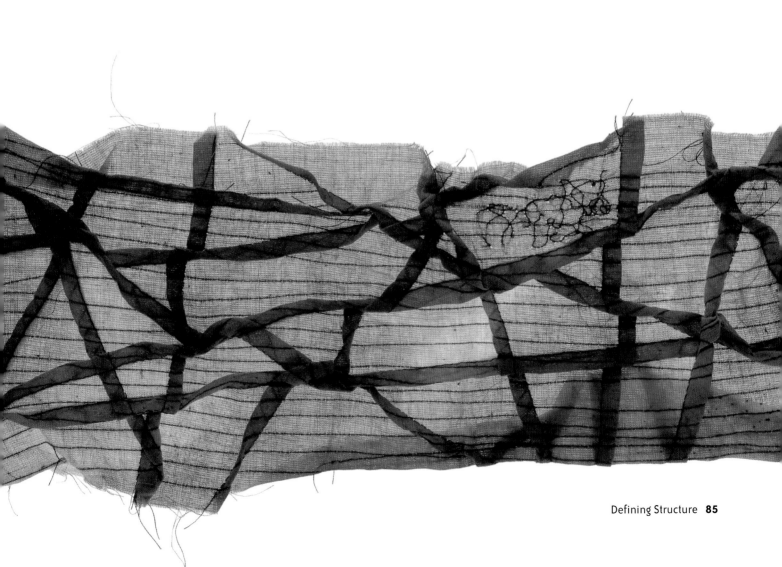

Fibre optics

In contrast to natural light sources, manufactured commercial lighting offers further development and visual interest that is another way of defining the structure either externally or internally. Fibre-optic cable, also known as optical fibre, is a glass or plastic fibre that carries light along its length. As well as being used in communications, applied science and engineering, fibre-optic cables are used for illumination where light is required.

A light source is placed at one end of the cable or fibre. The light is then bounced from side to side along the length of the fibre, a process that is called total internal reflection. The light can travel great distances in this way, enabling illumination far from the original light source.

The most familiar fibre optics are the ones that are known as end-emitting fibres. These have tiny points of light at the end.

Fibre optics can be used singly or in bundles. When placed individually in a work, they will provide tiny pinpoints of light at their tip. The most familiar image of bundles of fibre optics are the type of lighting used in the 1970s, which has a mushroom form created from thousands of fibres, bound tightly together at the base.

Coloured fibre optics are not actually coloured. If you add a colour wheel to your light source, then it will be the illuminated colour that is sent down the fibre. In commercial decorations, particularly at Christmas, you will often see fibre optics that change in sequence; this is achieved by a revolving colour wheel at the lighting source.

As well as end-emitting fibres, you can get sparkle fibre, which emits spots of light at regular intervals along its length. You can readily purchase the necessary equipment to add these light fibres to your work.

Fibre-optic fabric

You can buy special fabric that has optical cable woven into it to produce a cloth that shimmers and dances with every movement. The fabric can be lit from either one or both ends, to great dramatic effect.

Although this is a commercial product, there is still scope for exploration in your own workroom to weave and couch down these fibres into your own fabrics. They work particularly well with sheers and, when lit in a darkened room, the supporting fabric becomes barely visible.

An exciting approach is to target this type of light in specific areas where you want to enhance or strengthen a particular form or shape.

As with everything, experimenting and incorporating fibre-optic materials into textiles is limited only by your creativity.

Right: Bundles of fibre-optic tubes
placed over a light source to illuminate
the tips, transforming them into tiny
points of shimmering light.

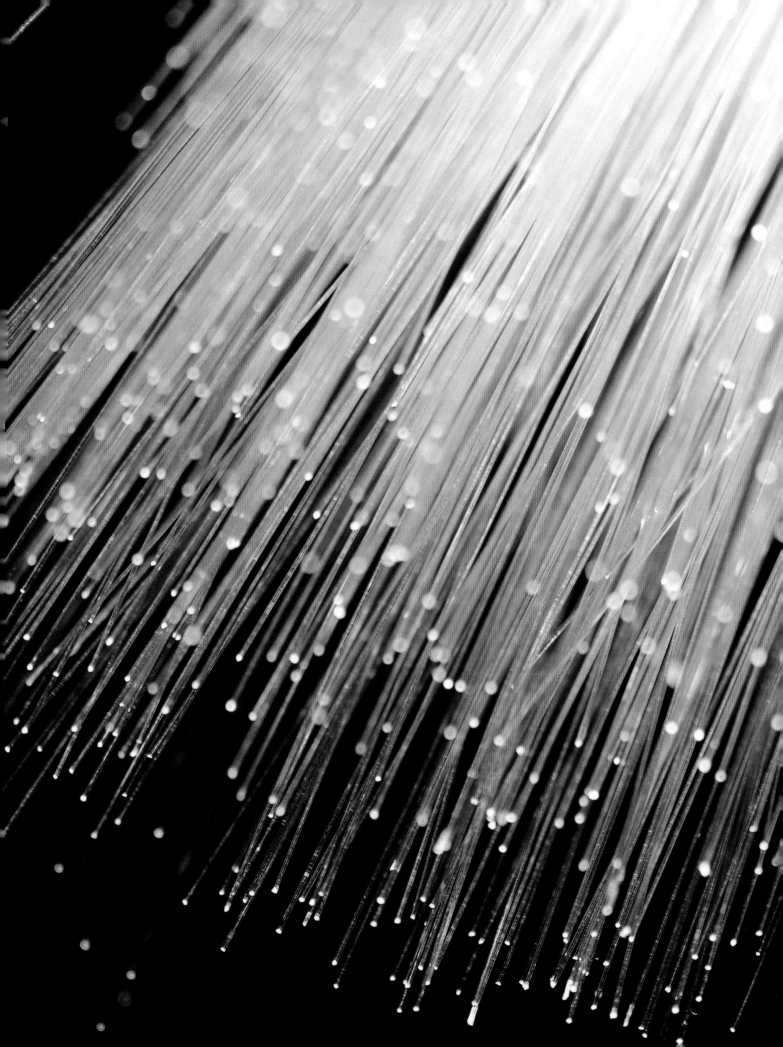

Artificial lighting

Although not necessarily used as part of the design, more traditional lighting methods will enhance the way transparent work is perceived. The properties of transparent media lend themselves particularly well to the creation of functional lighting pieces. Even almost opaque fabrics will alter when placed over a light.

One important aspect to remember when producing lit pieces is the way light interacts with and alters the appearance of the surface. It seems strange, as you would expect light to brighten fabrics, but they generally appear darker once lit.

Another aspect of the effect of light on a stitched surface is that the underlying stitching becomes just as visible as the stitched thread on top – something you need to consider when planning your design and stitch marks. For instance, if you work a line of running stitch on sheer or lightweight fabric and then hold it up to the light, what was just a row of individual stitches on the surface becomes almost a continuous line running through the fabric, as the stitches on the underside also become visible. Depending on the degree of translucency of the fabrics used, the appearance of the underlying stitches will vary in depth of colour, but they will still be visible, no matter what.

This is something to remember when adding stitch, particularly hand stitches, to any work in which lighting is an integral part of the final piece. If you want to add stitched texture to highlight a certain aspect of a translucent dimensional shape, you must make sure that you stitch less that you would normally. This is because any thread underneath will also become part of the detail, and what appears to be sparse on top shows up as a dense area as the light is filtered through.

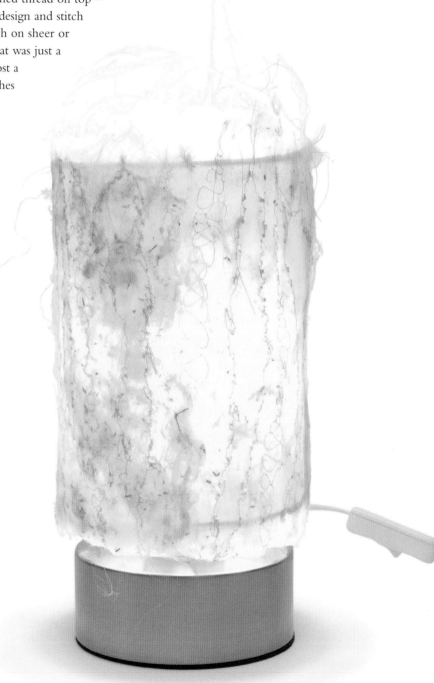

Right: A commercial light fitting with a silk paper and fabric shade. The colour of the shade is intensified by the artificial light source, bringing the layered design and stitch into play.

Opposite page: *Shadow Play* by Janet Atherton. Screen-printed design on silk organza enhanced with areas of shadow work and chain stitch.

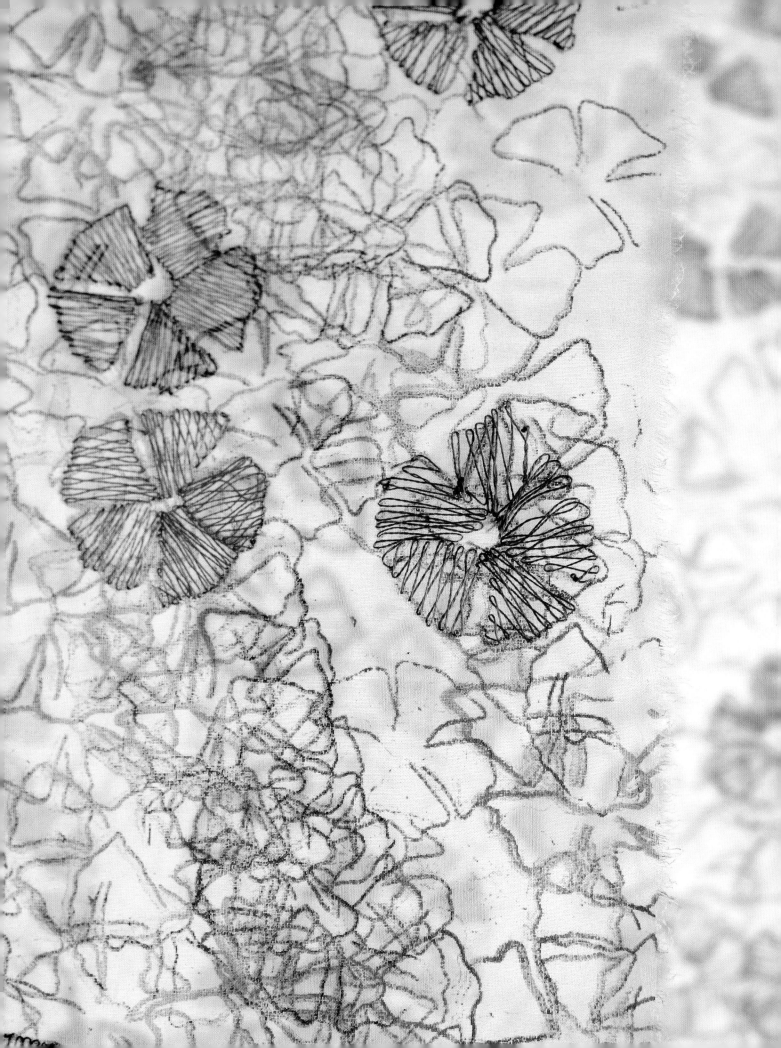

Lighting and the way you use light can be as much a part of the design concept as its other physical characteristics. The position of the light will impact on the work and produce shadows. These cast shadows can be more exciting that the work itself; in some cases, they may actually be the main event. Shadows can also offer support and strength and define the dimensional and structural qualities of a design.

Light passed through an intricate machined grid will throw shadows across a floor or wall, and as the light moves around, the length of the shadows will change. Placing the same grid against a wall, but standing proud of it, even if only by a couple of centimetres (1in), will give added depth and create a feeling of dimension and solidity, as the shadows echo and hug the stitch lines.

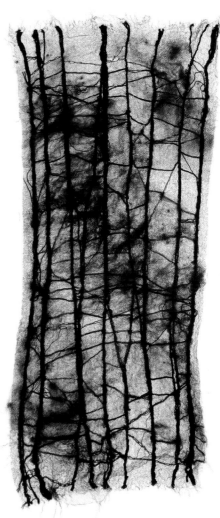

Top right: Machine-woven grid and silk fibres bonded between chiffon scarves.

Bottom right: Handmade felt and bonded chiffon, thread and fibre.

Bottom left: tissue paper folded horizontally and vertically showing different depths and intensities.

Opposite page: *Shibori Spheres* by Sharon Baugh. This piece exploits the properties of light, giving definition and detail to the manipulation of the fabric.

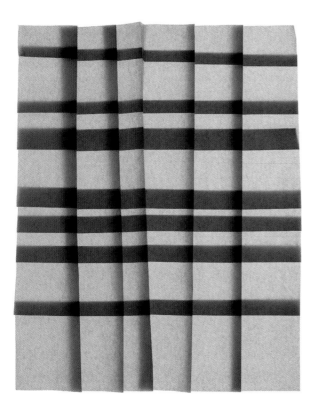

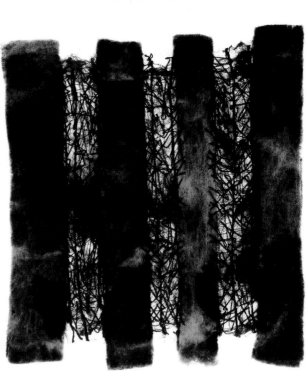

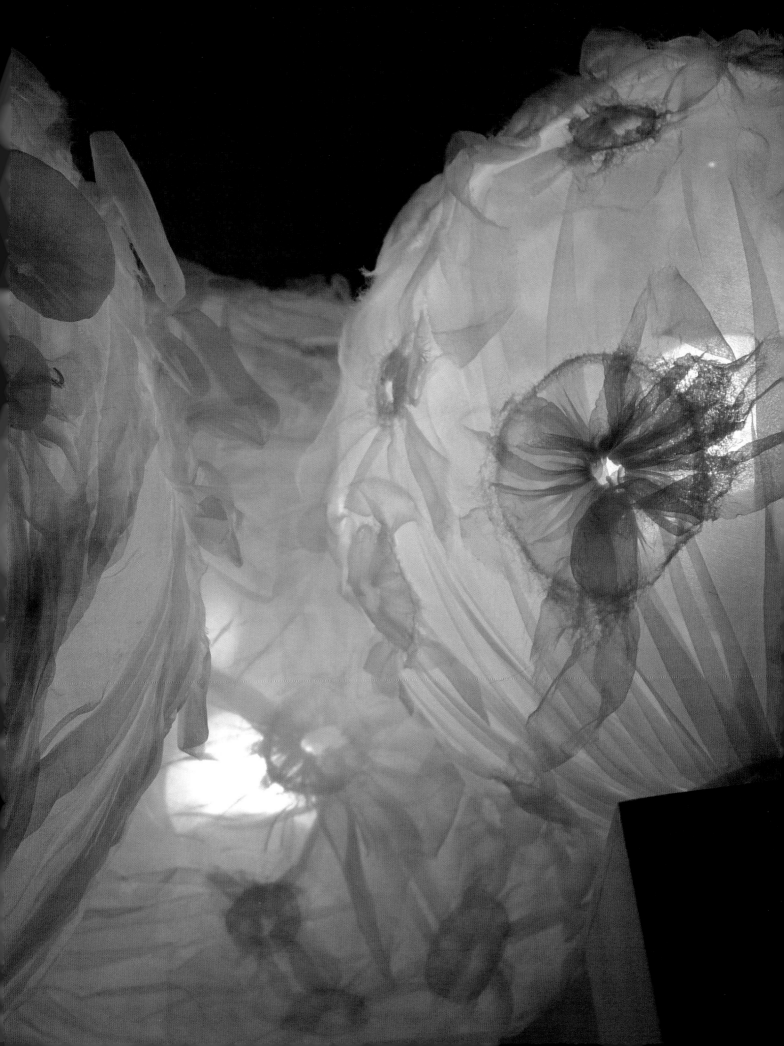

5 Inspiration

It can be quite daunting to be asked to produce a piece of work, particularly if you have no design source to inspire you. In reality this is rarely the case, as we are surrounded by images, textures and shapes that offer no end of possibilities and permutations when applied to design processess. Inspiration does not always jump out at you; sometimes you have to look a little more closely, and it is possible to find excitement in the most obscure or humblest of places. When looking for that initial inspiration for work in transparency, it is worth exploring imagery and objects that already have or give the impression of transparency or translucency, which can show up in some surprising places.

Around the home

In our everyday lives, we come into contact with transparent and translucent surfaces and materials all the time. On waking, as we look out of the window, the window frame acts as a portal to images and structures, familiar and pleasing compositions for the eye to see, clear and defined.

A visit to the bathroom illustrates how varying levels of transparency come into play. The obscured glass allows light to enter, softening and diffusing strong sunlight into the room. We can see out, but nothing is clear. Distorted images, shards and fragments of shape and form are seen; the eye cannot assemble the true image, but memory helps us out. The shower screen provides discreet blurring of the human form, giving a sense of security and keeping our modesty intact. The fact that the resulting image is not so familiar enables further exploration for design development that is not dictated by what we think we should see.

Softened light falls from draped voiles in the living room, the pleats and soft folds forming complex patterns that change as the sun moves in the sky. Or think of the dancing effect that happens at an open window as the fabric gently wafts to and fro giving rising and falling levels of obscurity.

The humble vertical, louvred or slatted wood blind can provide exciting and complex design starting points and ideas with which to explore aspects of transparency through illusion.

The natural environment

A walk in the winter woods provides us with another aspect of transparency through layers. As our gaze looks upwards, branches form complex lines and connections that reach out. These organic networks enable us to see a little or a lot of the landscape and sky that lies ahead. Although the trees are not in the slightest degree transparent, the open spaces between the branches give the viewer the ability to see beyond. The thickness of the lower heavy forms, solid and sparse in their outline, are in marked contrast to the plentiful but delicate frond-like structures of the higher branches. Shadows cast lines, marks and shapes that inspire you to look beyond the solid forms.

Right: Inspiration from nature.
Photograph by David Thorne.

Delicate wings of flying insects are amazing to look at in detail or through a magnifying glass; the fine networks that span across the wing surface, supporting the most fragile, transparent and sometimes iridescent material, are something to wonder and marvel at.

Look through and into rock pools. As light fragments and reflects back at you, creatures and plant life take on magnification and alter in colour. Put your hand into the water and make ripples and anything that is submerged ripples as well, distorting and moving in time and rhythm with each other.

Water droplets, bubbles and curtains of water all have transparent qualities. Remember how exciting it was blowing bubbles as a child, trying to see how large you could get them and seeing patterns and shapes reflected onto the shimmery surface?

Consider the way ripples in water create patterns across the surface. The lines created as a rowing boat or speedboat passes are very different to each other. Think of a swan landing and skidding onto a lake, creating a raised wake behind its path or the way reeds seem to bend when they lie submerged beneath the surface of a stream.

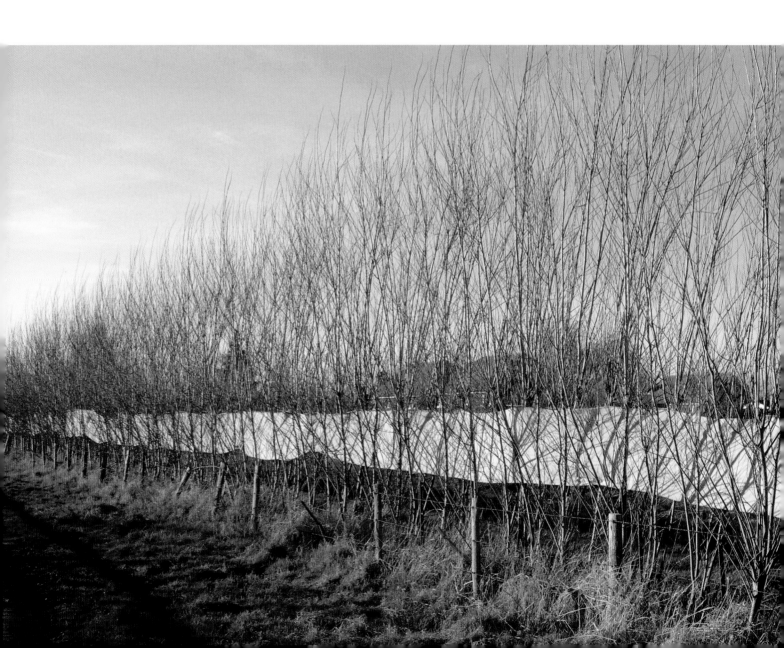

Above left: Handmade felt and sheer fabric pieced together in different widths, embellished with hand stitch. This piece was inspired by trees in a wood.

Left: *Bold Diffusions* wallhanging by Gillian Raine. Design elements filter through the transparent layers to bring together the complete image.

Right: *Pelion Stones* panel by Gillian Raine. Layers and layers of synthetic felt, machined and burned away, applied onto acrylic.

Buildings

Architecture can provide diverse inspiration for a whole range of applications, offering ideas for form and structure, surface and texture. Glass buildings allow you to enter the space without physically going inside. Angles and lines metamorphose into different shapes and patterns as you move around the building, creating different vistas and parallaxes, inspiring design approaches.

Glass and mirrored surfaces reflect and bounce light around in different directions, casting unfamiliar shadows and distortions. These sources can provide you with a wealth of ideas to explore.

Looking at structures can inspire the shapes and forms you create in your work. Trying to re-create those structures and considering the use of different materials and how they react within the form will give you insight into creating free-standing works.

The world around us is full of inspiration. How we view things, what we see and how we translate this visual information is a personal thing and should not be judged. But the more we look, observe and record our observations, the more information we will have to inform any work we create.

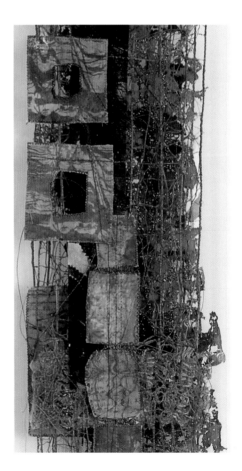

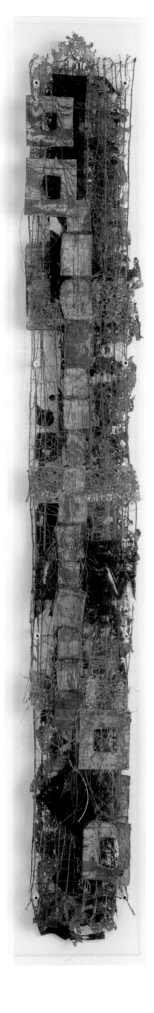

Right: *Deep Waters III* wall piece by Dawn Thorne. Perspex, textile, image transfer, metal, acetate and resin.

6 Designing for Transparency

The most important aspect of any work is its design. The design will either make or break a piece of work, no matter how expertly executed it is: if it is not right then the whole thing just won't gel. Design does not just happen; it evolves over time and is a culmination of visual awareness, thought and consideration, and familiarity with your materials. Often design can be frustrating – formalizing your ideas and thoughts into reality takes time, but for every ten designs you make, even if only one is successful then you have achieved your goal. Using a sketchbook to record information through quick sketches and supporting notes will help you remember what excited you about the subject when you get back into your workroom. Photographs can be useful to support your sketches, but should not be a substitute. By looking and recording as you draw, you will become more familiar with your subject far more than by using photographs alone.

Below: *Navajo Stone* by Dawn Thorne. Machine- and hand-woven structure, with silver and photographic film.

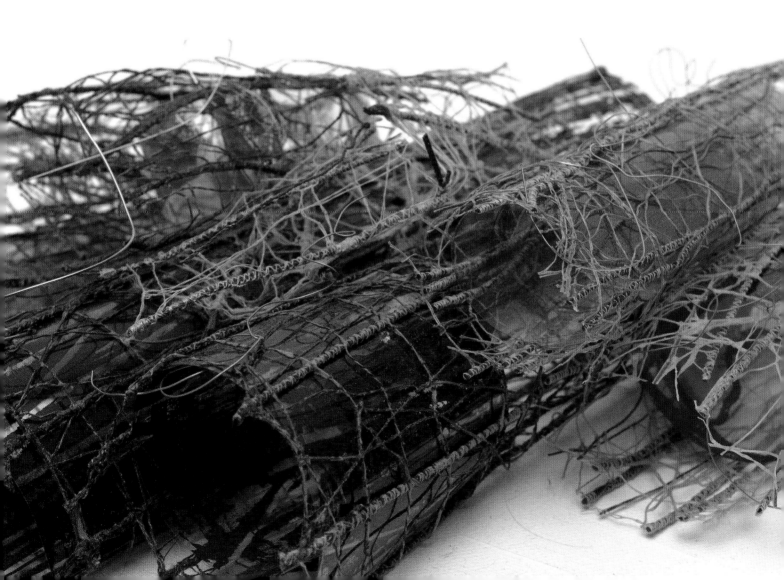

Left: Sketchbook page exploring the effect of the glassy quality of printed acetate. The images on the acetate have been extended onto the page with Brusho and highlighted with silver pen.

Below: Sketchbook page showing a build-up of both solid and transparent layers.

Bottom: Sketchbook page showing card shapes laminated between sheets of tissue paper. Graphite wax was rubbed into and across the surface to give definition.

How to translate your source

Working in dimension throws up certain challenges. When interpreting a design source, translating it from the two-dimensional sketchbook to the three dimensions of the finished piece of work can be a daunting task.

Working in a sketchbook will allow only limited exploration of dimension. However, initial design ideas and concepts can be recorded and these may be the starting point for a range of developments.

Some degree of relief and layering will work within the sketchbook pages and give you an indication of how to carry out the design process. But nothing can give you a better way of understanding the structure and how it will be created than making a series of 3-D or dimensional drawings. In a way, you need to begin drawing in space. Constructing and manipulating papers, wires, sticks and so on will give you an idea of what happens when, for example, you bend card in a certain way or twist or scrunch paper. Refer to Worksheet 3, page 122, for some structures and forms to explore.

Practise linking and joining sections together to form a structure. The simplest example would be to take four pieces of card, all the same size. By joining them together with sticky tape, with the final edge joining the first piece, you can make a square or rectangular shape.

One of the most important aspects that you have to think about when working with dimension and three-dimensional form and structure is that, unlike a one-plane surface, you will have to remember to think about what happens at the front, sides, back, top and bottom of the piece you are constructing. This is even more necessary when you are working with transparent materials.

Consider the following:

- Will your structure be viewed from different directions?
- Is it freestanding?
- If you are just raising the surface a little, then how high?
- Will just the front, sides, top and bottom be visible?
- Do you want to achieve a different set of visuals from the varying planes?
- Are the layers (if there are any) designed to be viewed as the sum of the whole?
- Alternatively, will each layer be separate in its own right?
- Are the front and back different; do you wish to convey two opposing images?
- What happens to the edges?
- Is the form organic in its nature?
- Is it geometric?
- Does it look different at every conceivable angle?
- Will the form be constructed from a number of repeated units?

All these questions need to be given some thought during the design process. Not all considerations will apply; it will depend upon your desired outcome and your interpretation of your original source.

Begin by doing a series of exercises:
- Work spatial and relief drawings, using shapes from your chosen source
- Change the scale
- Repeat the same unit

Above: Quilt sample. The addition of the black silk organza has an impact on the underlying surface, but still allows the imagery to be seen, albeit subdued.

Below: Individual shapes constructed from synthetic sheer fabrics, manipulated and formed into a dimensional structure.

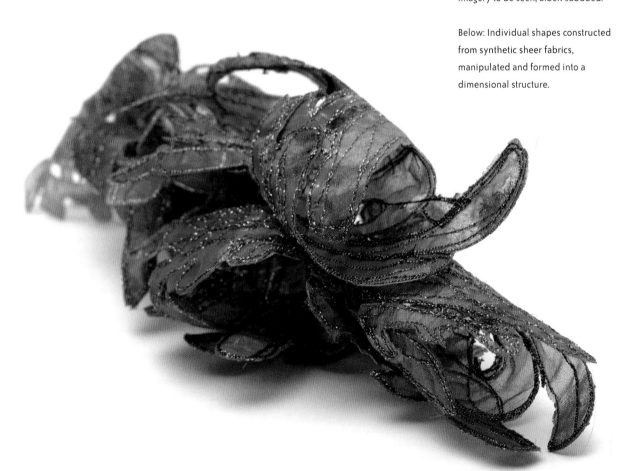

Relief drawing as a design source

Relief drawing

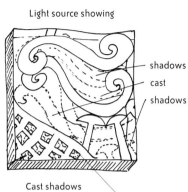

Light source showing

shadows

cast
shadows

Cast shadows

Blow up image of shadows
and enlarge as a drawing

Detail of shadows cast from
the windows in the grid
section of the relief drawing

Note and show the tonal qualities
and value of the shapes created
by the cast shadows

Create pattern repeats

Incorporate
appropriate words

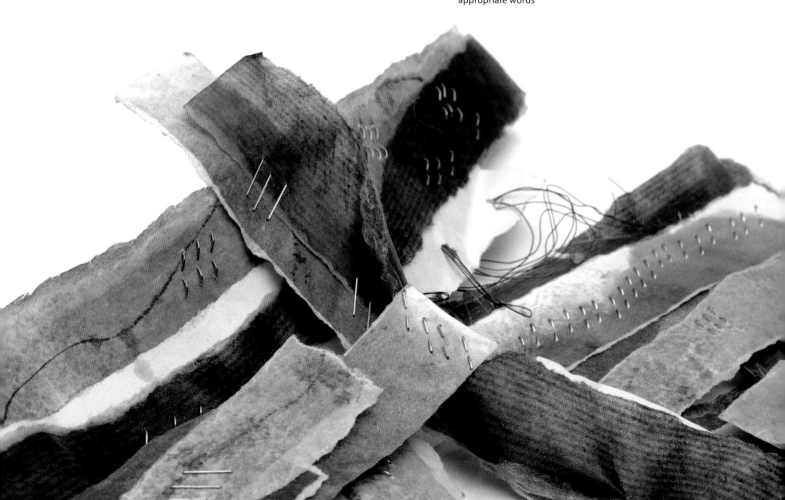

A relief drawing

You will need:
- A shoe-box lid or something similar, painted white or lined with white paper
- Thin card
- Double-sided tape
- Pencil
- Scissors

Method:
- From your own drawings or a selected source, isolate a shape. Translate this onto card and cut it out. For example, if you choose a spiralling line, make a spiral cut-out shape (see Worksheet 2, page 121). Try to avoid too complicated a detail, as this may be difficult to translate. Simplify the shape if necessary. Cut several shapes.
- Begin adding shapes across the shoe-box lid, working with the box side facing up. Make sure that the card cut-outs stand proud of the base.
- Once you have completed the relief drawing, use the visual information to record observations. The relief cuts will cast shadows on the base surface of the box lid. These will create new shapes and varying values of tones and shades, which can be used to inform your design work.
- Try throwing different light intensities onto the relief drawing to give variations in shadow strength.
- Change the position of the light source, as well as your viewing point.
- Make drawings of these to record the differences.

Noting how the light alters the overall effect will help you when deciding how a final piece of work might be lit to achieve the desired result.

Creating and interpreting structure

Another way to translate your source is to attempt to construct what you see, using papers, card, twigs, sticks, wires and any other found objects you may have lurking around the house.

Take a spiral staircase, for example:
- Look at the stair risers; note and draw their shape.
- Count how many there are and cut that number from card.
- Using a wooden barbecue skewer or length of dowel, position the card risers around this central core.

You have produced the basic shape which, with further detail, could become your mock-up. Should your source be more organic, such as a rose on a stem with leaves, the construction approach would also be more organic.

- You might use galvanized wire to represent the stem, for example.
- Cut leaf shapes from tissue or paper and place a length of fine wire down the centre of each shape, leaving extra to attach and wind around the stem. The addition of the wire will allow you to manipulate the paper shapes into the curve of the leaf.

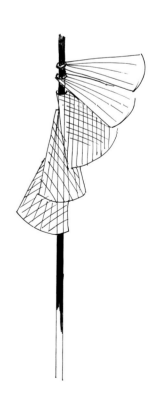

Below: Design work – dimensional form created using waxed and oiled papers.

- For the flower head, look at the petals and observe their shapes. Are they all the same? Do they vary in size? How many are there? Is the centre different? If so, how?
- Make simple drawings of the shapes you see, and then cut these out in paper.
- Begin to construct your flower head in the same way that nature does, by attaching them around the central part of your constructed paper flower centre.

Deconstructing your original source, drawing the elements that make up the whole, cutting them out in paper and card and using wires to help manipulation is a quick and easy way to learn how to produce a dimensional drawing.

Now you have produced this in paper and so on, the exact same principle and method can be used to produce the textile work. Instead of the papers and card, select appropriate materials: for the rose, chiffons, fine sheers and fine silks could be used, for example. Alternatively, you could produce the petals and leaves by free machining on a soluble base or using a combination of materials.

Either galvanized wire that has been wrapped or machine-wrapped cords, twisted together around a central core, would make a suitable stem.

Below: Waxed cartridge paper, with cut apertures echoing the design, gives low-relief and dimensional qualities. In addition the 'windows' let light through, revealing imagery behind.

Working dimensionally

The most immediate way to create dimension from a flat plane is to make relief cuts into the surface and bend them, creating little window cuts, or make flaps as explained here.

- Take an A4 sheet of paper and mark out a grid across the surface.
- Using a craft knife or scissors, cut out alternate squares. Only cut out three sides, as you need the fourth to act as a hinge. Do this across the whole sheet.
- Note how light casts shadows and the sheet of paper has become dimensional, creating little structures at each cut. Take photographs of the shadows and make notes of how the shadows change as you turn the paper. If the sunlight is strong, dramatic, bold and black, shadows are cast, but if the day is overcast, then the resulting shadows are softer, lighter and less pronounced.

Further experiments:
- Try cutting different shapes, such as rectangles, triangles or even hearts.
- Instead of working in a grid, cut out shapes along a line, varying the angle of the fold or whether you fold to the right or left.
- Change the height of the cut shape. Tall shapes will produce longer shadows than shorter ones. Cut shapes from within shapes.

Right: Diagram showing how to cut and fold the paper.

SOLID FORMS

A technique to transform a shape into a dimensional form is to look at it and produce it from a number of pieces of flat card. Take an image of a cube, say 1cm (½in) square. Cut out several squares from thick card. Stack them on top of each other to a height of 1cm (½in). Glue all the pieces in place and a simple cube shape will have been formed.

You can do this with any shape, even more complex ones, or shapes that have cut-outs so you can see right through them.

Repeat the same exercise, but this time make each square, say, 5 x 5cm (2 x 2in), and then cut out a 2cm (¾in) diameter circle from the centre of each. Repeat the process until you have a solid block with a hole running through it.

Below: Waxed cartridge paper, with cut apertures echoing the design, gives low-relief and dimensional qualities. In addition, the windows let light through, revealing imagery beyond.

LOW RELIEF

Low-level relief can be produced using the same principle as geographical physical contour maps. Similar shapes are cut and stacked on top of each other to produce a raised surface. The layers can reflect undulations and rhythms over its surface and contours.

- Take some corrugated card and cut out a series of shapes that reflect your image. Glue these in sequence to a base support.
- Raise some areas up higher than others and undercut some crevices from the top surface so you can run you hand over and under the top part of the structure.

This method also works well with cut acrylic or plastic shapes. Try screen printing or marking each layer of the sheet. The colours or designs will show up through the layers to give further detail and design elements.

An alternative slant on using flat pieces to construct a form is to arrange a series of similar shapes in a sequence.

Above: Stacked card in reducing sizes offers visual interest. Worked in acrylic sheet, this technique could give exciting possibilities. Trapping materials between the clear layers could add further opportunity for design development.

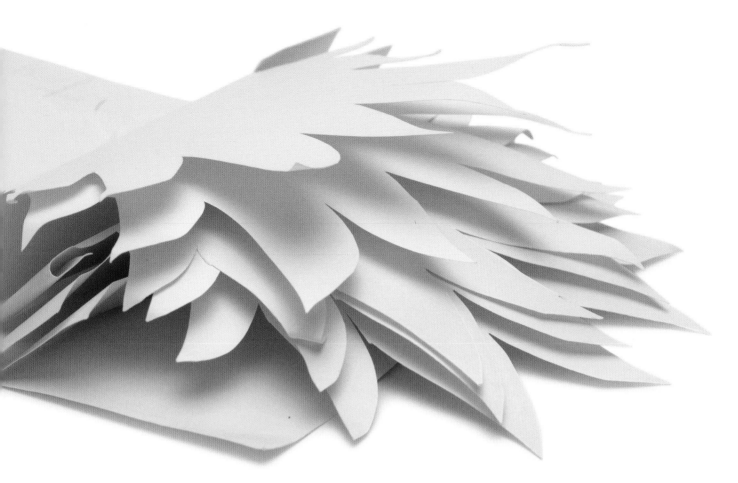

You will need:

- Thick card or board
- Thin card
- Double-sided sticky tape
- Scissors or craft knife and cutting mat

Method:

- Select a shape from a source or drawing.
- Draw it on a piece of thick card.
- Use this piece as a template.
- Place the template on thin card and draw around it.
- Remove the template and draw a long, thin rectangular strip at the bottom of the shape. Try to make this the width of your double-sided tape.
- Cut out the shape, including the strip, which will act as a support or hinge.
- Repeat the process a number of times.
- Each time you draw around your original template, you can either enlarge the shape by about 2 or 3mm (⅟₁₆ or ⅛in) and/or decrease it in size. If you change the size, number the cut shapes in order, so they can be placed in sequence to form an undulating shape.
- Once you have all your numbered cut pieces, apply double-sided tape to the rectangle, and then bend it at right angles to the main shape.
- Remove the protective strip from the tape and, starting at one end of the thick card or board, secure the hinge to the card surface.
- The next and subsequent hinges need to be positioned as close as possible to the previous hinge (see the diagram on page 121).
- Continue to add tape, bend the hinge and adhere the shapes until you have used them all up. (Remember to place them in sequence.)

Above: Cut-paper shapes attached to a base paper, manipulated to form the illusion of a dimensional structure. Working this exercise with transparent materials and sheer fabrics opens up all sort of possibilities.

What you now have is a dimensional structure that echoes the chosen shape. The eye fills in the gaps and creates a visual dimensional form. Once the shapes are standing upright, you can play around with bending and manipulating them and record the most important differences.

Try other shapes, varying the way they are placed on the support card. Place them in a curve or S form, for example. Gradually change the starting shape from a square to an oval or circle.

Working in this way lends itself well to producing large-scale textiles and sculptural pieces. The resulting puzzle only becomes a form when it is a sum of its pieces. This enables large structures and forms to be assembled in situ and makes transport to the site easier. It may also be possible to change the shape by arranging the elements in a different order, as long as it produces an equally successful shape. It's essential to factor in this variant at the design stage.

Below: Individual patches of sheer shot organza positioned next to each other build up to create a rectangular shape.

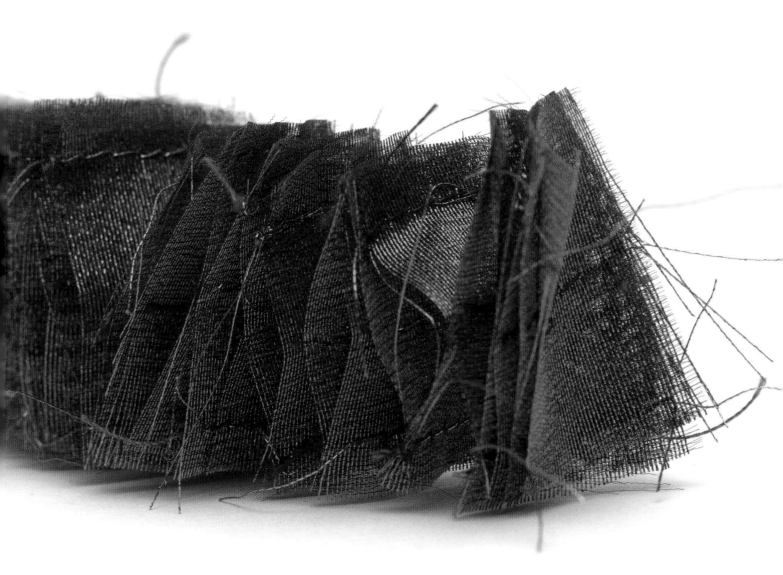

7 Projects

Over the next few pages you will see how you can take some of the techniques and ideas explored in this book to inspire pieces of work. Firstly, there is a wall- or window-hung hanging that utilizes the qualities of light through a transparent layer to build up the overall design. Next is an item of jewellery using metal and textile cast in small resin blocks, together with embroidered patches worked as separate elements that come together to produce a shimmering bracelet. Another project explores dimension through manipulative processes and the transparent quality of sheer fabrics to give a dimensional hanging that can be suspended from a ceiling. All the projects are designed to get your thought processes going and should not be thought of being set in stone: fabrics can be altered as you wish to enable you to produce pieces of work that are unique to you.

Out From the Wall

This project is a wall-hung work that consists of three layers, to create depth and dimension. It is an exercise in looking at the completed design image through a series of layers: the overall design is a sum of its parts, with each layer supporting the next. At the design stage, you need to remember that all the elements of the final piece must work successfully together. Make sure that there is visual interest throughout and that the work does not appear top heavy or the design imbalanced. Using a light box or light source such as a window is crucial, as it enables you to see the whole design clearly.

You will need:
- Sketchbook or paper to draw on
- Drafting film or thick tracing paper, 20 x 50cm (8 x 20in)
- Thin card
- Thick card
- Three pieces of tissue paper, each 20 x 50cm (8 x 20in)
- Scissors
- Craft knife and cutting mat
- Glue stick
- Fineliners
- Masking tape

Method:
- First you need to choose a shape to use as the main element of the design. As a source to inform the work, select either a photograph or one of your drawings.
- Use a pair of L-shaped pieces of card to isolate a particular section. Rotate the Ls to see if a more pleasing or interesting shape becomes apparent. Now draw this shape in your sketchbook or on some paper. Enlarge the shape, if necessary.
- If the shape you have chosen is too complicated or too busy, simplify it by removing any fine lines or details. You might even enlarge it and select an area with your Ls again, in which case you may only be using a small section of your original shape.

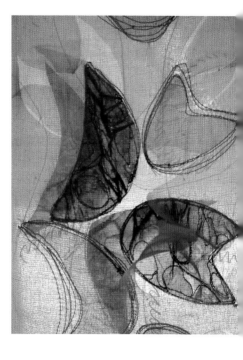

Above: Detail of the finished *Out From the Wall* wallhanging.

Right: Image showing the translucent layers. See how the design on the bottom layer is filtered through. The overall design is built up through these layers.

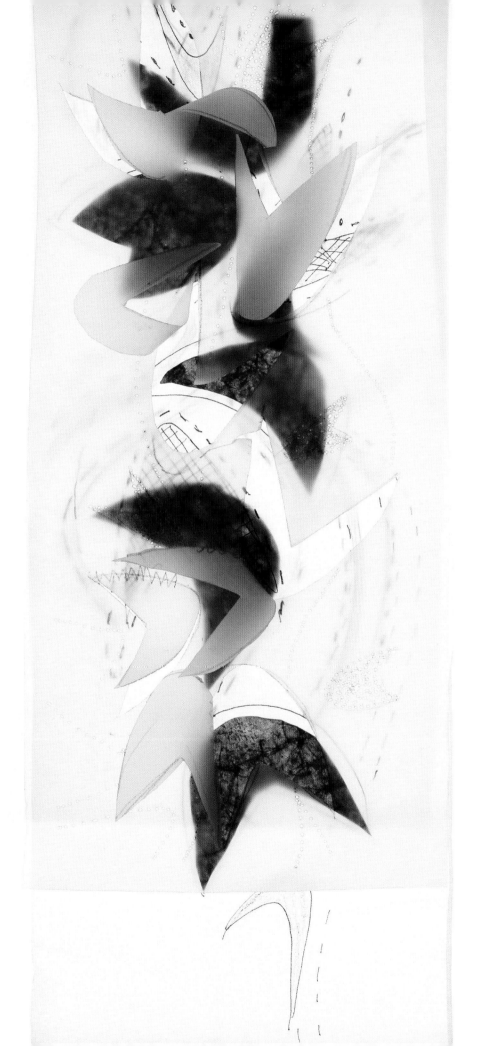

- Now you need to alter the scale of your shape. Decide which would be more appropriate to your shape and draw either one 10cm (4in) and one 5cm (2in) square or one 15 x 7.5cm (6 x 3in) and one 7.5 x 2.5cm (3 x 1in) rectangle. You can also adapt your shape by stretching and condensing the original (see below).

- Next, select an element from your chosen source. You should end up with three shapes: one large, one small and one element from your original source. Now make templates of all three from thick card. Once you have your range of shapes, you can start the design process.

- Draw around the templates on the thin card and cut them out. Make a number of each size. This will allow you to play around with positioning them. Too few will limit your composition. Lay out a sheet of tissue paper and arrange the cut shapes in a composition on top. Note that there will be another two layers to complete the whole design, so keep it simple at this point. Use the rule of thirds to help your placement (see Worksheet 5, page 124).

- Glue the pieces in place. Next, put another sheet of tissue over the top to make a sandwich. Glue this in place. Fix the sandwich to a window with masking tape or place it on a light box.

- Now take the third sheet of tissue and place it over the sandwich layer, fixing it with masking tape or again using the light box. You will be able to see the card design through the tissue.

- Using the position of the card shapes on the previous layer, draw the same shapes onto the second layer. Remember that the design will be combined through all three layers and that you will need to make sure that you do not obscure part of the design on each previous layer.

- Once you are satisfied with the paper mock-up, you can select suitable fabrics and threads to carry out the project. In the sample shown, cotton organdie has been used in place of the drafting film, and sandwiched and bonded sheers for the other layers. Hand and machine stitch was used to reflect the marks of the fineliners. Machine stitch without thread was worked with a wing needle.

First layer

Second layer

Third layer

Precious Metals

Metal, resin and textile are combined in this bracelet.

For the design process, you will need:
- Brown paper which has been treated with charcoal, oil and emulsion, as explained on page 29
- Tissue painted with gold paint and waxed
- Treasure Gold
- Incense sticks
- Acetate sheet
- Metal wire

Method:
- Take the brown paper and tear a number of squares out from it. Tear rather than cut, as this gives a more interesting edge. Vary the size of the pieces, but work with a size range of 5–7.5cm (2–3in) square.
- Fold each square in half and tear out a square from the centre. Leave an adequate margin, but again vary the sizes.
- Rub Treasure Gold along the edges of some squares and burn with incense sticks along others to give definition and interest to the edges.
- Take the painted tissue and repeat the tearing exercise, but this time make the pieces a little smaller. Cut out squares from the acetate.
- Select different squares and begin to link and join them together with the wire. Overlap some of the squares and position them at different angles.
- Continue to arrange the squares until you are pleased with the result and have worked a length that fits around your wrist. Once the design is complete, you can begin to make the actual item.

MAKING THE BRACELET

You will need:
- 5 x 30cm (2 x 12in) strip of copper or aluminium shim
- 50cm (20in) of Bondaweb (Wonder Under)
- One chiffon scarf in a colour of your choosing
- 200ml (6.8 fl oz) of resin and the required catalyst
- Small mould
- Wire
- Glass seed beads
- Hand and machine threads
- Fabric and thread snippets
- Sewing machine and sewing equipment
- Embossing tool
- Silk paint
- Iron and ironing surface
- Baking parchment
- Soldering iron

Method:

- Mix up some resin and catalyst, as previously explained (see page 76), and pour the liquid into a small mould. A mould approximately 2 x 3cm (¾ x 1¼in) will be fine, but you can go bigger should you wish. Only fill the mould halfway (see page 80). At this point, you can add anything to be embedded, before you complete the process.

- Make four or five blocks. These will correspond to the acetate squares in your design mock-up. From the metal shim, cut out squares to correspond to the painted tissue paper in your design mock-up. Place these onto a padded surface and, using an embossing tool, draw into the surface to add some texture or design.

- Paint some Bondaweb (Wonder Under) with the silk paint and leave to it dry. You can use a hairdryer to speed things up. Take your chiffon scarf and iron the Bondaweb strip to one half of it. Place backing parchment between the iron and the ironing surface so the fabric is sandwiched between the Bondaweb and the paper. Remove the backing paper from the Bondaweb and sprinkle it with the fabric and thread snippets. Fold the remaining part of the scarf over the top to cover them. Place baking parchment on top and iron, bonding the layers together.

- Set your sewing machine up for normal sewing and stitch through all the layers, working the stitch in a meandering line all over the surface. Add further embellishments with hand stitches or free machining.

- Use the soldering iron to cut out squares, including the middles, to correspond to the brown paper shapes. The soldering iron will seal the edges at the same time as cutting them out. Add seed beads to the individual squares for the final embellishment.

- Once all the elements have been prepared, use wire to assemble the bracelet in the same way as the trial piece. The resin blocks can be drilled and threaded or you can simply wrap them with the wire and secure them to the fabric or metal elements.

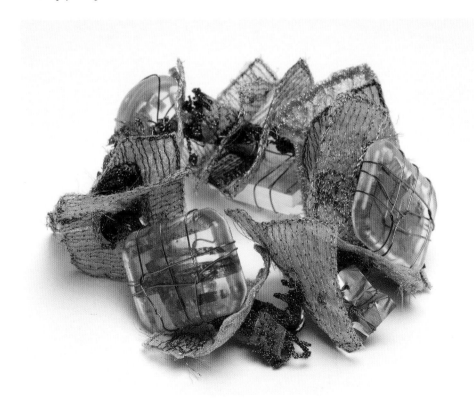

Left and right: The completed piece of jewellery, showing the various components, including copper shim, sheer patches and cast-resin elements.

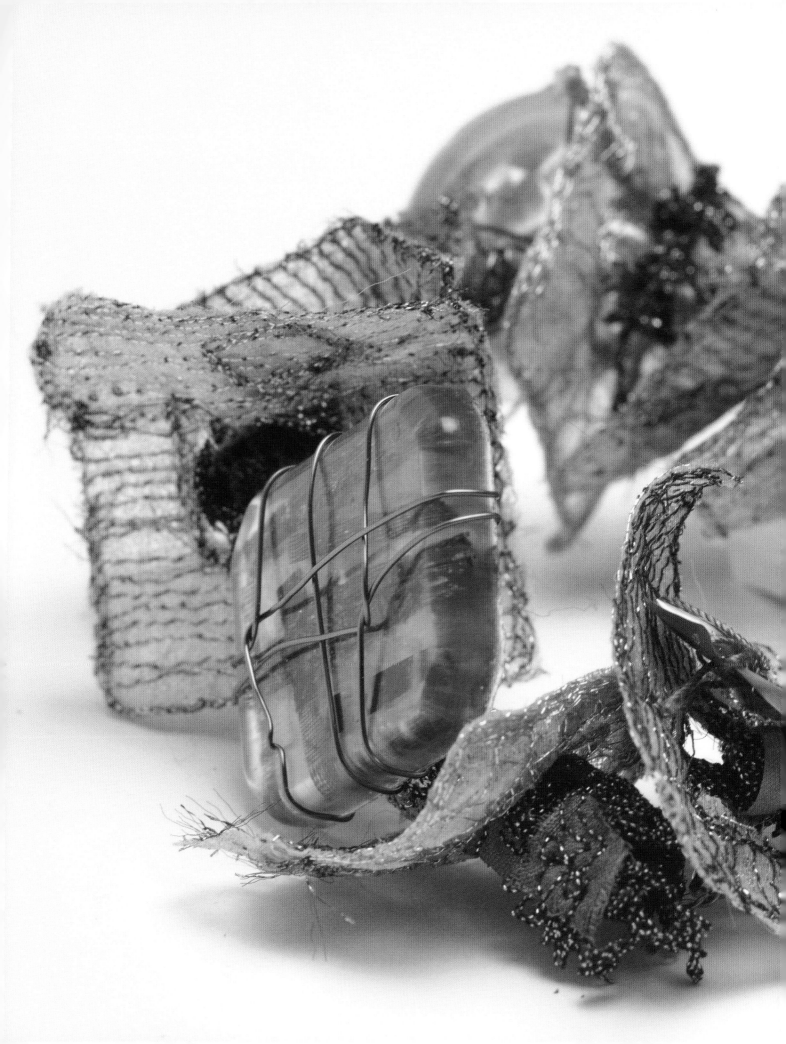

Hanging by a Thread

A manipulated and sheer dimensional hanging.

Opposite: Pleated rectangles of organza, manipulated, linked and joined to create an undulating structure, showing shadows and varying levels of transparency.

For the design process, you will need:
- Coloured or white tissue
- Ruler
- Sewing thread
- Needle

Method:
- Cut out 12 pieces of tissue paper, each 30cm (12in) square. Pleat these at regular 1cm (½in) intervals across the diagonal and then fold each square in half.
- Stitch the folded squares together, three along the width and four down the length. Leave a length of thread between each joined section.
- Now take the top three threads and tie them together about 30cm (12in) above the piece. You can play around with the folds; change the widths of the pleats, and vary the stagger between them to change the overall look.

For making the piece, you will need:
- 90 cm (1yd) of 120cm (48in) wide sheer fabric, such as crystal organza (this could be all one colour or you could select different colours, but in total you will need 12 pieces, each measuring 30cm/12in square)
- Sewing machine and machine-embroidery thread in a matching or contrasting colour (if you are using a shot fabric, try picking out one of the shot colours)
- Tape measure or ruler and scissors
- Fine cord, approximately 5m (5yd) in length

Method:
- Cut the fabric into 12 pieces, each 30cm (12in) square, and set up the sewing machine for straight stitch. Pleat the fabric across each square along the diagonal. Work evenly spaced pleats on each square. You may vary the size of the pleats, should you prefer, but plan this beforehand, at the design stage.
- Once all the squares have been manipulated, take the two opposing corners across the pleats of a square and pull them. Watch as they fold in half of their own accord. Secure with stitches at the points where they meet at the top. Repeat with all the squares and set them aside.
- Next, make a length of machine-wrapped cord, using the machine-embroidery thread and cord. (The cord could be dyed beforehand, if you choose.) To do this, set your machine for free machining and set the stitch to zigzag, with the stitch length at zero. The stitch should be wide enough to allow the needle to swing from side to side and pass over the cord, not into it. Holding the cord firmly in place under the foot, work zigzag along the length, working in a backwards and forwards movement.
- Use the covered cord to link the pleated squares together. Tie and secure them in place, joining them across the width and length, leaving the ends free for added detail. Finally, stitch and secure a length of machine cord to the top of the first row of points and attach to a metal or plastic ring, painted dowel or Perspex rod.

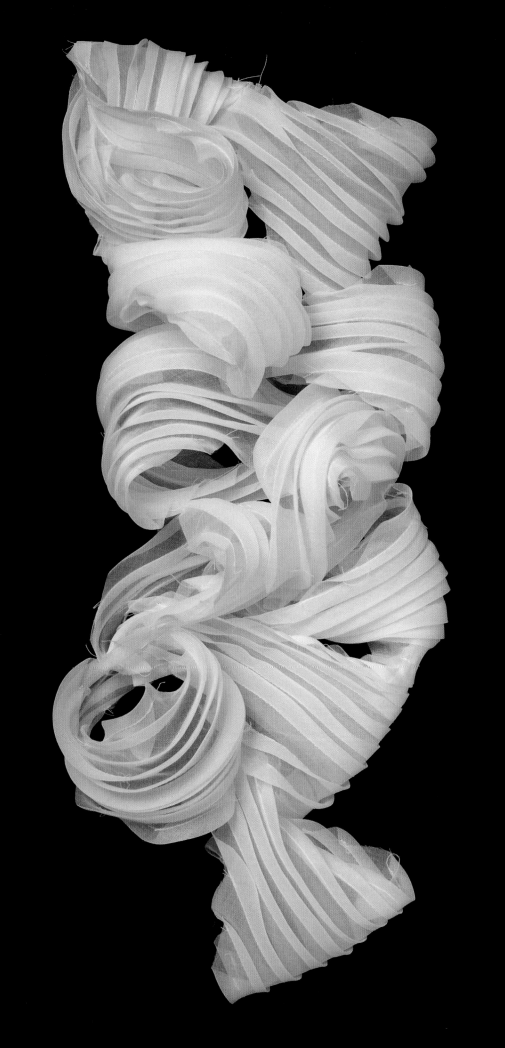

8 Presentation

One of the difficulties that can arise when you work with transparent materials is deciding how you will display the final work.

The work itself might have been made to fit a particular site within a space. If this is the case, then the surrounding area where the piece will eventually go must be looked at, measured in detail and then considered in the design process.

- Are there windows nearby that will alter the overall perception of the work, or do you actually need a window in order to make the work how you want it?

- Will an overhead light or other fixed light source affect viewing when lit, and does it matter? Or does the light play an integral part in the method of display?

- When will it be most likely to be looked at – during the day or at night?

- Does the work need its own light source? If so, are there electrical sockets nearby or will one need to be installed?

Sometimes you may need to add a light source if you are working to a client brief and are looking at the whole installation process. Working with electricians and builders often has to be considered. This, however, is generally something that only a few textile artists are faced with. Most of us will produce work that will be hung in homes or exhibited in galleries and exhibitions.

If you are making something for yourself, to hang in your own home, it becomes relatively easy to ascertain where it is going to be placed and the method of hanging it.

When the work is to be exhibited, on the other hand, it is most definitely advisable to look at the space, either during or prior to the making up. The same rules apply to lighting, but this time you need to ascertain where your piece will be placed within the gallery. If you have been allocated a certain place to hang your work, check that there are electrical sockets nearby. If not, you should request a move. If you notify a gallery in advance that you require sockets, they can plan ahead accordingly, making it less likely that there will have to be last-minute changes.

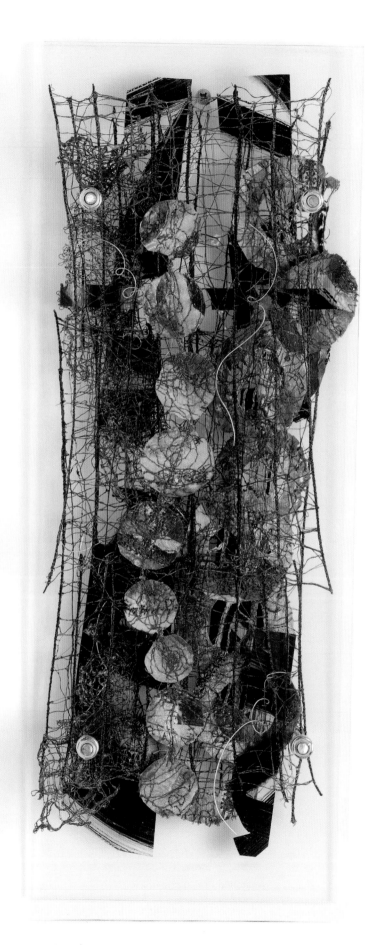

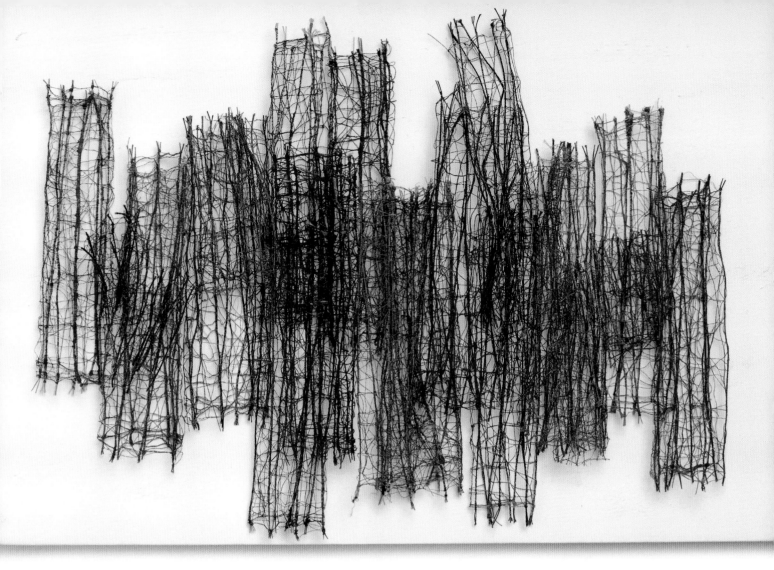

If your work is to be presented as a free-standing piece, check how much space it occupies and then assess whether there will be enough space to enable visitors to walk around and view it properly, without bumping into walls or other works.

Do you want the work to be displayed on a plinth? If the plinth is set low on the ground, you need to ensure that it does not protrude significantly from underneath your displayed work, causing a potential tripping hazard. If you want to raise the work quite high above the ground, make sure it is not so high that it cannot be viewed properly.

As well as thinking about the size and shape of plinths, you may actually have to produce them yourself or find someone who will. Most galleries have somebody you can use to prepare a plinth, but they may not be able to produce one to your specifications. It is wise to make sure that you can provide your own, should you need to.

When work is intended to be wall hung, this makes life a little simpler, as you only need to consider how it will be looked at from the sides and front. The consideration now is the method of hanging. Is the hanging mechanism part of the overall design or a major part of the piece or does it need to be hung in a discreet and unnoticeable manner? If it is a panel and quite rigid, then a picture hook or screw may be all that is needed. But if the work is transparent or translucent, you may find that the hook and wire are visible. To lessen this problem, use fishing line instead of wire for the hanging thread. Fishing wire is barely visible, but the wires come in different poundage weights, so make sure you choose one that will take the weight of your work.

The hook should be painted the same colour as the walls. Check that the gallery has spare paint you can use, of the same colour as used on the walls. Nothing looks worse than a mismatched dot of paint against clean walls.

Above: *Desert Colours* wall panel by Dawn Thorne. Free-machined open structures applied and layered with stitch onto an artist's canvas that has been treated with clear gels.

Opposite: Freestanding piece from the *Illusion of the Bullfight series* by Dawn Thorne. Acrylic-treated tissue with resin-dipped, machine-stitched, screen-printed acetate and silver wire.

If the work is a wall hanging, it needs to hang from a pole or something similar, so the pole itself has to be considered. Transparent textile materials are generally fine and lightweight, and if you have a beautiful white floaty organza hanging, the last thing it needs is a heavy-looking wooden pole. You may need to paint the pole white or some other appropriate colour. The most pleasing solution, however, is to use an acrylic rod or tube.

Fishing line can be tied around the ends and the line can be taken up and sometimes over display boards. If this is not viable, cup hooks, painted the same colour as the walls, will provide a discreet alternative. The rod can then be slotted into the hooks.

Another way in which you may want your work to be displayed is to have it suspended from the ceiling. This requires considerable thought and discussion with the venue owners. Not all spaces will have suitable facilities to allow this; again, this is where it pays dividends to have prior knowledge of the venue and to work with gallery owners. Chains, wires and suspension cables will need to be sourced, and any drilling, erecting and construction work must be agreed with the gallery's contractors. Sometimes, extra costs can be incurred if special arrangements have to be made. Knowing this in advance will help you to allow for it in your budget.

If the costs make your preferred hanging method prohibitive, an alternative method may need to be found. Perhaps, for example, you could provide your own false ceiling that could be hooked into place. This gives the minimum of disruption to any existing framework, and the only holes that need to be made are in your own construction. As with everything else, it's essential to confirm with the owners that it is all right to use your own installation methods.

Communication, planning and allowing enough time to carry out all these additional considerations is the key to a successful exhibition and one that is as stress-free as possible.

Right: Wall-hung screen from the *Illusion of the Bullfight* series by Dawn Thorne (detail). Acrylic-treated tissue and silk fabrics, screen-printed acetate film, free-machine embroidery and silver wire.

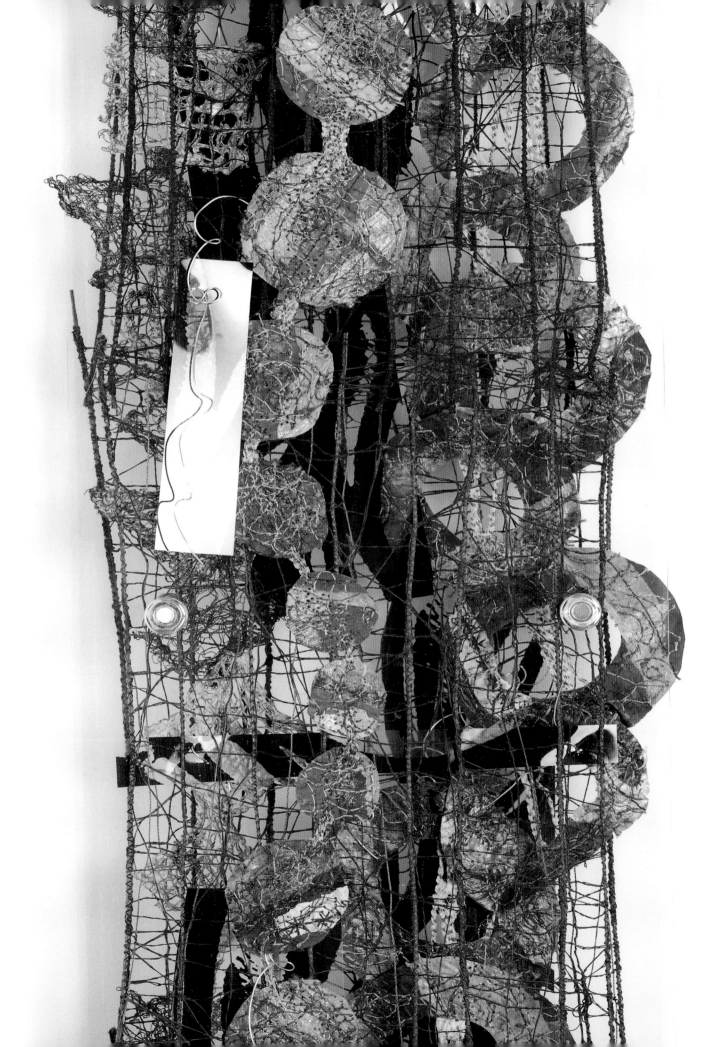

Worksheets

The five worksheets on the following pages give further ideas for experimentation and design.

WORKSHEET 1: Change of scale, thick and thin, repeated pattern, random pattern, vary the widths. Explore tonal value, light and dark.
Line and mark-making

Straight lines Meandering lines Points and dots

Unusual shapes

Cylinders joined together in random fashion

Cones

Three-dimensional architectural
structures – archways

Little pyramid structures made with cocktail
sticks or toothpicks and paper or fabric

Pieces of card of varying
thicknesses and heights

Cut spiral or any shape from paper

Pull up and suspend by a thread

Cut out shapes and place on support

WORKSHEET 3:
More structures and
forms to explore

Randomly weave twigs and sticks:
try bending the structure

Twine twigs, sticks, straws etc together,
varying the widths, lengths and thicknesses

Manipulate into shapes such as cylinders

Crumpled paper forms:
cornucopias, flower shapes

Create open wire cages

Make plaits and form into
coils, bowls etc

Cones

Cut slits in card. Build up and
assemble into structures

Wrap fine wire over shapes, then string them together, or build up forms

3-dimensional shapes:
rectangles, squares, rhomboids etc

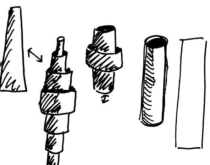

Long and thin wrapped-
paper beads

Short and fat wrapped
cylinders

Make a variety, then string
or join together

Cocktail sticks and straws
can be linked together with
paper

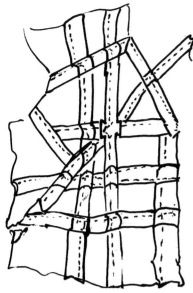

Random pleats, worked on the horizontal, vertical and diagonal

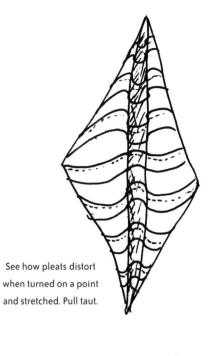

Pleat on the diagonal grain of the fabric

See how pleats distort when turned on a point and stretched. Pull taut.

Play around with distorting gathers

Use smocking pleats to create fine, uniform gathers.

Chenille: Layer fabric, stitch on the cross and slash through down to the first layer

Wrap and stitch

Slash and fray: Slash through two or more layers at the same time

Pull: Slash on the diagonal then pull and stretch to open out the cuts

Make shallow ruffs, stitch, gather and form into coils. Join to make a fabric.

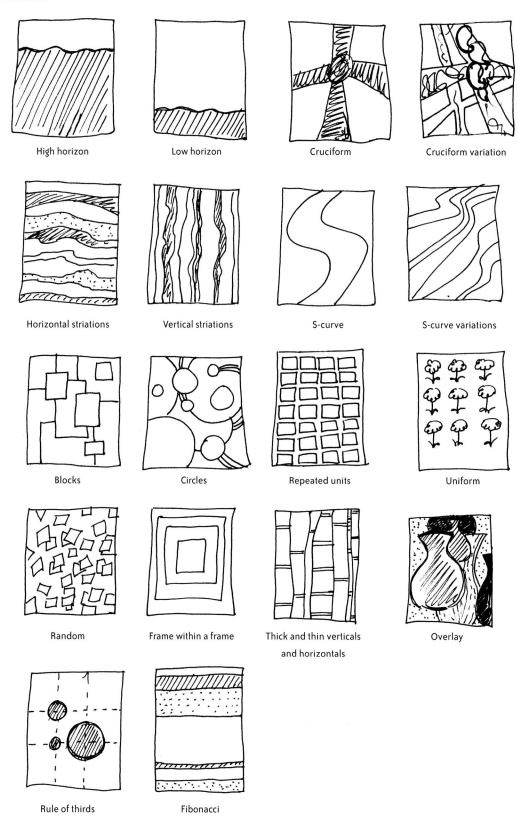

High horizon Low horizon Cruciform Cruciform variation

Horizontal striations Vertical striations S-curve S-curve variations

Blocks Circles Repeated units Uniform

Random Frame within a frame Thick and thin verticals and horizontals Overlay

Rule of thirds Fibonacci

Suppliers

Art Van Go
The Studios
1 Stevenage Road
Knebworth
Hertfordshire SG3 6AN
Tel: 01438 814 946
www.artvango.co.uk

Freudenburg Nonwovens
Lowfields Business Park
Elland, West Yorkshire HX5 5DX
Tel: 01422 327 900
www.nonwovens-group.com
Non-woven fabrics

Whaleys (Bradford) Ltd
Harris Court
Great Horton
Bradford
West Yorkshire BD7 4EQ
Tel: 01274 576 718
www.whaleys.co.uk
Fabrics

Kemtex Colours
Chorley Business and Technology Centre
Euxton Lane, Chorley
Lancashire PR7 6TE
Tel: 01257 230 220
www.kemtex.co.uk
Dyes

Oliver Twists
22 Phoenix Road
Crowther
Washington
Tyne and Wear NE38 0AD
Tel: 0191 416 6016
Threads, fabrics, fibres

Spunart
1 Park Lane
Allestree
Derby DE22 2DR
Tel: 01332 554 610
www.spunart.co.uk
Lutradur, Evolon

The Plastic Shop
16 Bayton Road
Coventry CV7 9EJ
Tel: 0800 321 3085
www.theplasticshop.co.uk
Acrylic sheet, rods and tube

E Sheet Ltd
Tel: 01773 881285
www.esheet.co.uk
Plastics

East Coast Supplies
Unit 2B, Rekendyke Industrial Estate
South Shields
Tyne & Wear, NE33 5BZ
Tel: 0191 497 5134
www.ecfibreglasssupplies.co.uk
Casting resins, mould-making sundries

Fred Aldous Ltd
37 Lever Street
Manchester M1 1LW
Tel: 0161 236 4224
www.fredaldous.co.uk
Casting resins

The Essentials Company
Springfields, Station Road,
Pulham St. Mary
Diss
Norfolk, IP21 4QQ
Tel: 01379 608 899
www.theessentialscompany.co.uk
Cellophane rolls, tissue, brown paper

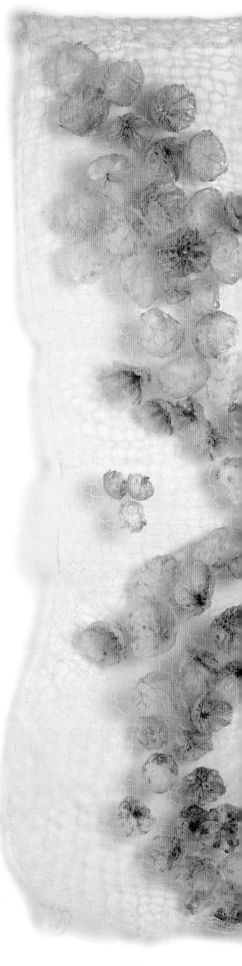

Right: Window hanging by Wendy Creak, made from knitted thread stiffened and used as a support for the dimensional structures, which are made from bonded sheer fabrics.

Further Reading

Beal, Margaret. *Fusing Fabric: Creative Cutting, Bonding and Mark-Making with the Soldering Iron.* Batsford, 2005.

Beaney, Jan and Jean Littlejohn. *Complete Guide to Creative Embroidery.* Batsford, 1997.

Beaney, Jan and Jean Littlejohn. *Stitch Magic.* Batsford, 1998.

de Sausmarez, Maurice. *Basic Design: The Dynamics of Visual Form.* Herbert Press, 1987

Freisner, Edith Anderson. *Colour: How to Use Colour in Art and Design.* Laurence King, 2001.

Issett, Ruth. *Colour on Paper and Fabric.* Batsford, 2000.

Itten, Johannes. *Colour: The Basic Course at the Bauhaus and Later.* John Wiley & Sons, 1975.

Itten, Johannes. *Design and Form: The Basic Course at the Bauhaus and Later.* John Wiley & Sons, 1975.

Jerstorp, Karin and Eva Kohlmark. *The Textile Design Book.* A & C, Black 2000.

Oei, Loan and Cecile De Kegel. *The Elements of Design: Rediscovering Colours, Textures, Forms and Shapes.* Thames and Hudson, 2002.

Bramley, Sylvia. *Embroidery with Transparent Fabrics.* Batsford, 1989.

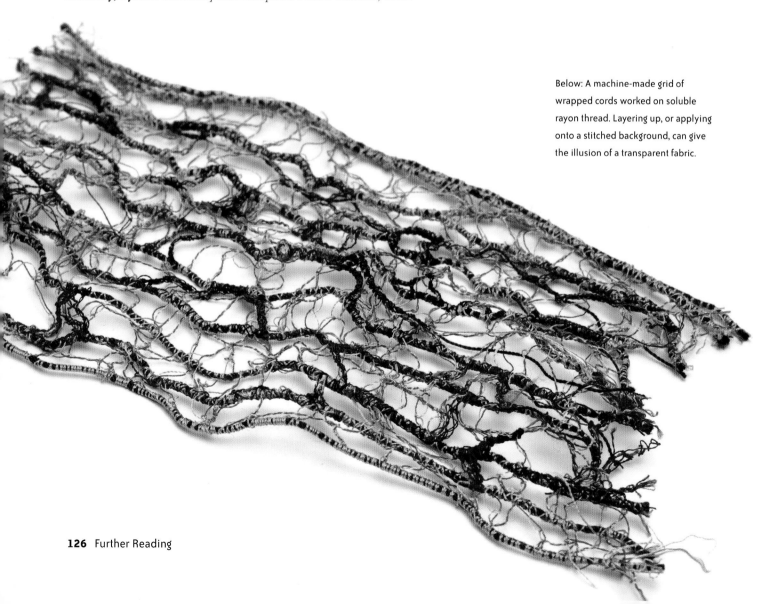

Below: A machine-made grid of wrapped cords worked on soluble rayon thread. Layering up, or applying onto a stitched background, can give the illusion of a transparent fabric.

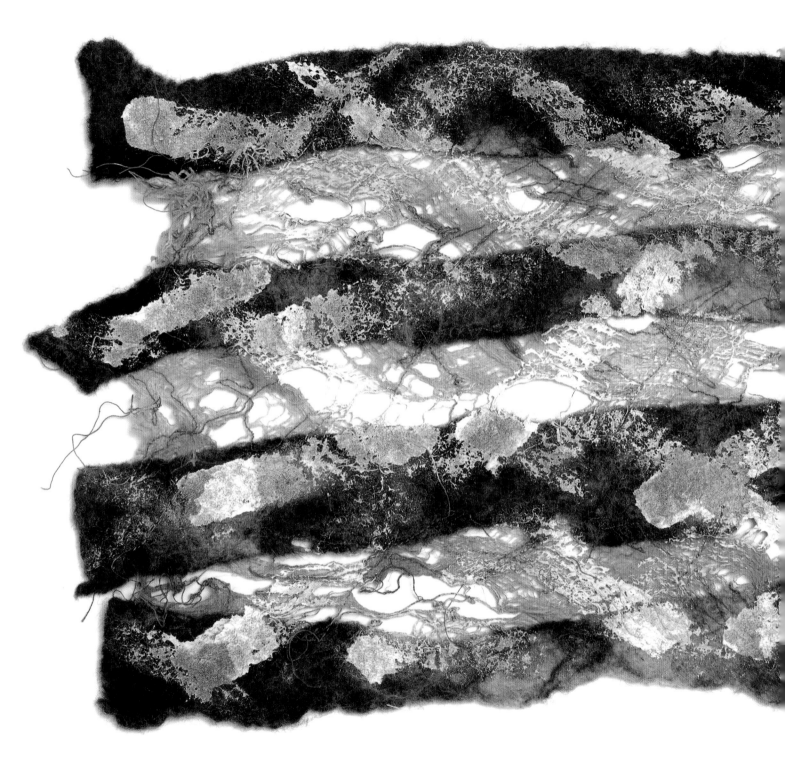

Above: Acrylic paint and gesso worked over a
handmade felt and coco-fibre insertion piece, with
areas of transparency between the felt. This
sample was inspired by a vertical blind.

Index